COMPAI MOVEML.... DEALS AND DRINKS

Kathrin Böhm, Miranda Pope (eds)
Myvillages

JAP SAM BOOKS
2015

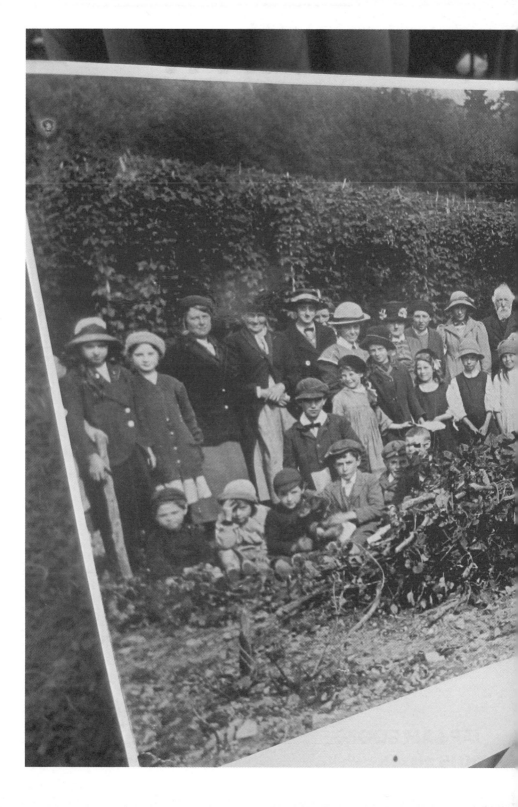

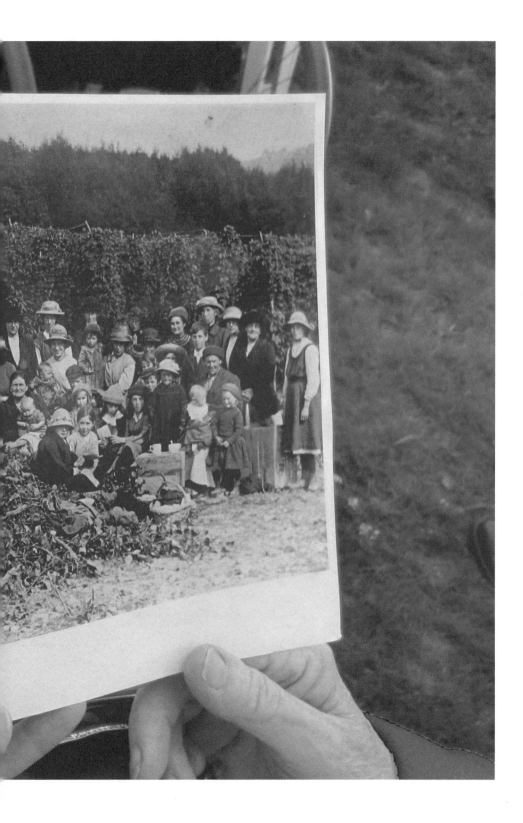

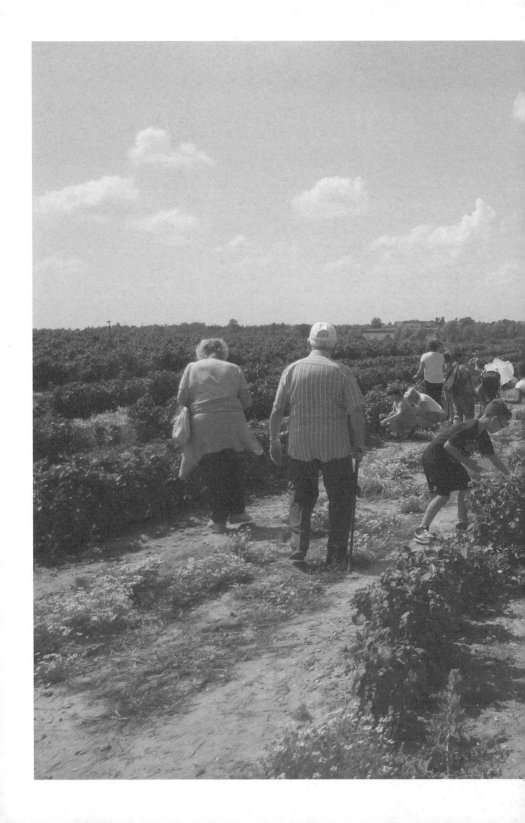

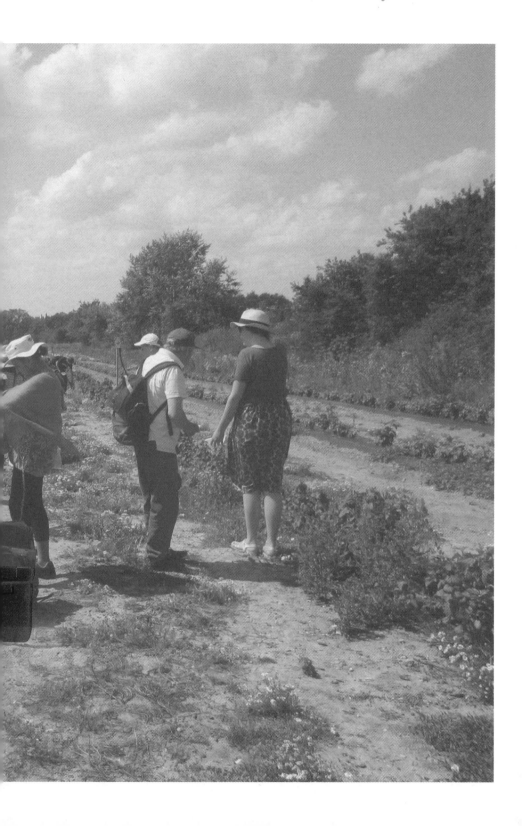

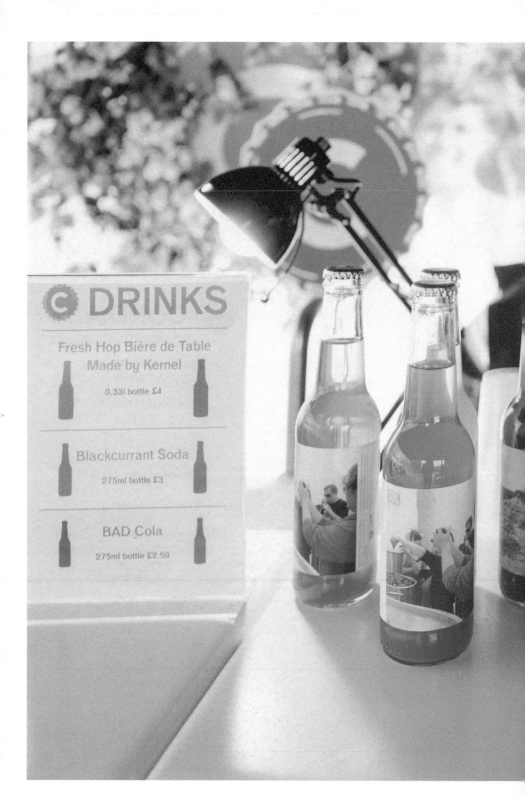

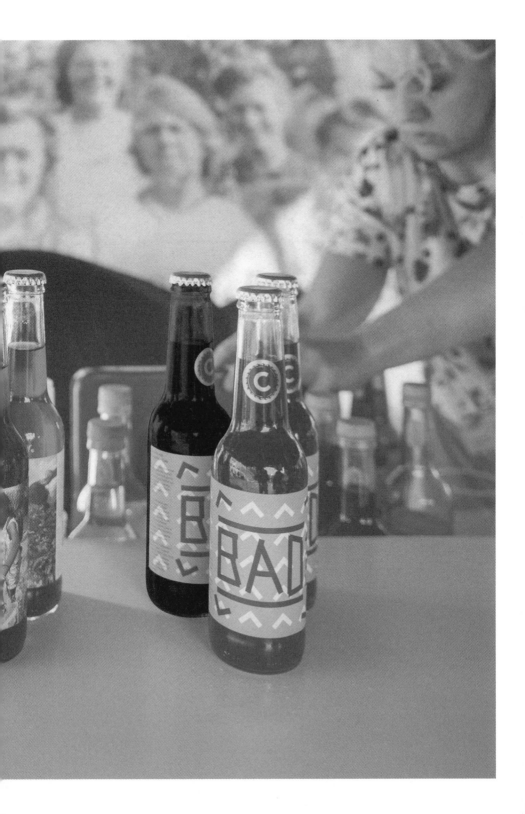

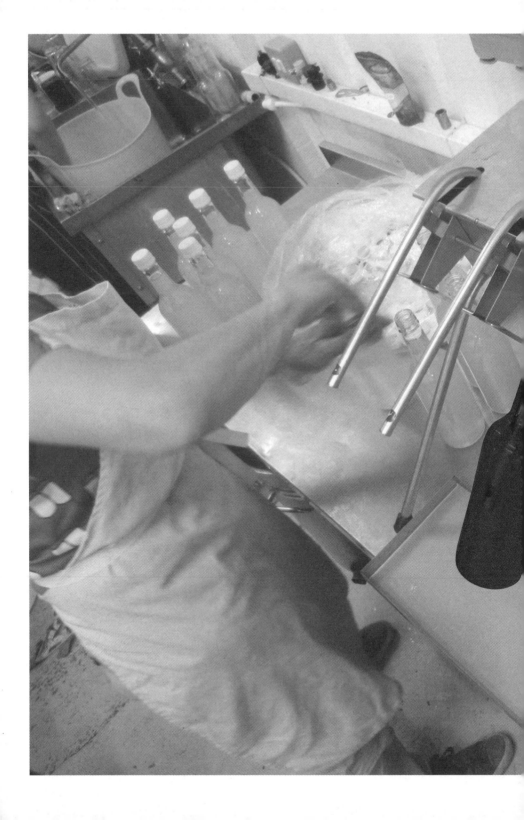

CONTENTS

INTRODUCTION

Between the early 1800s and the 1950s, up to 250,000 East Enders – mainly women and children – would leave London every summer to go fruit and hop picking in Kent, a 'working holiday' in the countryside which offered some income, fresh air and temporary independence from the everyday drag. This unique urban-rural relationship and culture survives vividly in the memories of those who went, and is the starting point for **Company: Movements, Deals and Drinks.**

Company: Movements, Deals and Drinks is an arts project in the shape of a community drinks company. It exists within a busy network of local and non-local individuals, organizations, places and ambitions, and it touches on a broad range of issues. It addresses the histories and politics of access to land and the countryside, local agricultural and industrial production, shared working class culture and new collective identities, practices of commoning, community economies and non-pecuniary values, and the possibilities for setting up new urban public realms.

Based in the Outer London Borough of Barking and Dagenham – home to the enormous Becontree Estate where many former hop pickers relocated to after WW2 – the project revisits the lived culture and shared history of the 'picking days' whilst extending the collective labour process further to complete a whole cycle of production, trade and reinvestment into a new kind of company. Since May 2014 residents from the borough have been going picking again in their local parks and the nearby countryside. Individuals and groups have been involved in the making, labelling and distribution of a new drinks range. To date, the project has produced five different sodas, a DIY cola, beers, twelve cordials and saps. Sold at various events and outlets locally and within the wider art world, the proceeds are used to develop this community enterprise into a lasting public and productive public space for the area.

Company: Movements, Deals and Drinks is an endeavour in the making and this book opens a window onto the different aspects and aspirations of the project, from the logistics of making and trading drinks, to cultural and political motivations and practicing new economical cultures. The book is part of the project's making, and reflects its real time production, messiness and clarity.

Kathrin Böhm, Miranda Pope

The discursive backbone of the book are Miranda Pope's four main project essays: 'Company', 'Movements,' 'Deals' and 'Drinks'. Each chapter follows and analyses different stages of the productive and reproductive cycle of the project, describing and expanding on the multiple anticipated and practiced meanings within the project's four-word title.

The book uses the full range of the visual imagery used and produced in the project so far, including family photos from former hop pickers, archive photos from the local museum, snapshots on the move, commissioned documentation, product shoots, design work by An Endless Supply and concept sketches.

Included are also contributions by other writers that frame and explore the wider context and disciplines within which the project is situated. Gilda O'Neill collects stories about the lives and culture of hop pickers, through the voices of the women who went picking. Her portraits reveal the multiplicity of reasons that motivated the journey to Kent, not least an escape from the polluted London air. Céline Condorelli contemplates the inherent but mostly ignored presence of infrastructure and ideological implications of this. For Condorelli, revealing infrastructure becomes a political act in itself. David Boyle traces a brief history of the 'back-to-the-land' movement and explores the radical possibilities of current engagements with agrarian activities.

Constantin Petcou and Doina Petrescu of atelier d'architecture autogérée discuss their approach to developing diverse and resilient local economic forms in their project R-Urban, based in Colombes, a suburb of Paris. In building up networks of practice and ecological cycles, they are altering the ways in which the community relates both to each other wider societal changes. The civic structures within which the activities of **Company: Movements, Deals and Drinks** take place are also explored in a discussion between Marijke Steedman, curator of Create and Paul Hogan, the Divisional Director for Culture and Sport with Barking and Dagenham Council. Finally, Seb Emina offers an entertaining journey through contemporary cultures of drinking, commenting on socially instigated times and the use of unnecessary fluids.

COMPANY

Miranda Pope

Connecting Histories, Altering Practices

The project takes as a starting point the collective memory and shared history of east London working class communities going fruit picking and hopping in Kent and explores current local possibilities around a new collective 'going picking'. Based in the Outer London of Barking and Dagenham,1 **Company** sets out to introduce a new cycle of collective, productive and reproductive activities in east London, with the aim of establishing and growing a new type of company.

In the past, economic structures of 'going picking' that governed the harvest and subsequent drinks production and distribution processes meant that the urban hop pickers were only involved at two stages of the process – the picking of the hops in Kent, and once back in London, in the purchase and drinking of the final products.2 The publicly accessible and collective fruit picking, drinks production and trading activities of **Company** address these specific cycles and open up possibilities for alternatives.

The project reminds us of historical and contemporary ties between agricultural production and urban conditions and communities. It proceeds through a programme of reminiscing, planting, harvesting, production, tasting, skill-learning, discussions, trading and drinking with informal and formalized local groups, organizations and residents of different ages to launch a range of drinks made from fruits and plants picked in local parks and gardens, and the nearby countryside in Essex and Kent.

Company looks at the complex social currency and socio-political relations and economic conditions that structure realities of drinks production. Histories and politics are explored to navigate complexities of relationships between rural production processes, urban communities and local land use. By remembering local histories and small-scale drink production processes, and allowing for alterations through their revitalization, the project weaves multiple connections between notions of rurality and the urban, and aims to initiate new social, productive and economic structures within Barking's and Dagenham's communities, local land, micro-economies and social histories.

Acting from within a network of existing spaces and facilities, the project's workshops, events and bars are collective and collaborative spaces to work and be together. They offer opportunities to try out different activities related to drinks production, and to discover things through doing and sharing them in public. Workshop locations have included a country fair, a bench and a bush in a community garden, moving across a park, the under-used visitor centre of Eastbrookend Country Park, a local library, the college training kitchen, the back garden of a busy youth club, the kitchen and meeting room in an Active Age centre, a local farm and allotments.

COMPANY

Residents get involved in activities relating to the production of fruit drinks: taste-testing, soda production or drink mixing, for example. They include regular 'drink labs' – an experimental drink-mixing lab for young people, as well as sessions on making slush puppies and cordials, cola concentrate, designing labels, developing sales strategies and brainstorming business development.

Histories of 'going picking' and beverage production in the south east of England are equally addressed in the workshops and through public events. In the 1900s hop picking and harvesting were marketed to working class families in east London as holidays for pleasure and profit, and the annual mass movement of Londoners to the countryside was enabled by the development of the railway into Kent. Hop picking was most popular during the 1920s and 1930s, when train companies would often run 'Hop Picker Specials' to transport pickers as the season began. This history survives in the memory of many east Londoners today, who would have only been small children at the time, but who are from families who would have been going hop picking for several generations, and for whom this collective history is part of their family lore. Furthermore, the shared history of hopping is also important to Dagenham and the Becontree Estate in particular, because many of the people who moved to the estate came from the traditional East End where communities first went hop picking en masse. This mobility of the history and the shared experience of hopping are explored through one of the project's regular events, the 'Hopping Afternoons' held at Valence House Local Archive.3 The 'Hopping Afternoons' provide an informal setting in which to reminisce and learn about the collective experiences of this temporary transplant of an urban community into a rural setting. Those who take part are either interested in sharing their own personal or family history of going hop picking, or are generally interested in local history and social histories of east London.4

The recounted memories and other recorded oral histories suggest that 'hopping' was more than just an annual occupation or habit. The communal move from London to Kent seems to have given rise to a particular culture that could be said to be essential to the experiences of these hop picking families. In this rural setting it was a culture dominated by women, characterized by collective labour, simple living conditions and spare-time activities, coupled with the advantage of improving one's economic situation in the company of others from a similar urban background. Leaving London at the same time every year became more than an employment ritual. The work and the new living conditions were perceived to be a liberating break from the intensities of urban living, with women having more autonomy over the immediate day-to-day running of things as well as being able to earn a decent amount of money for themselves. Furthermore, the outdoor nature of the work represented an escape from the polluted London air, which was at the time always heavy with coal smoke. The quieter environment and the fact that the children

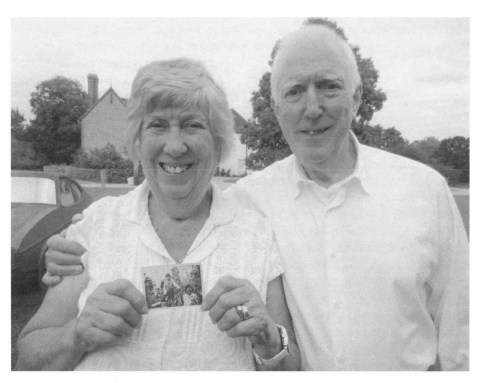

Left: Maureen Hostler and her brother Terry with a photo of them as children in the hop fields.

Right: Memories from Evelyn Hazard, collected during the monthly *Hopping Afternoon* at Valence House, Dagenham.

Personal Hopping Narratives

Name: EVELYN HAZARD Age: 65

Email:

Phone:

Current Location:

Notes/Memories: I WOULD LIKE TO GO ON TRIP IN SEPTEMBER,

MY FAMILY WENT TO NEW BARN FARM
IN YALDING FOR MANY YEARS. I HAVE
A PHOTO OF MY NAN, MUM AND SISTERS
TAKEN IN THE HOPFIELD IN 1925 WHEN MY
MUM WAS NINE.
I LIVED WITH MY FAMILY IN STEPNEY AND
WE WENT HOPPING EVERY YEAR.
I REMEMBER ONE YEAR WHEN ME AND MY
NAN TRAVELLED TO KENT IN THE BACK OF
A LORRY. WE WERE EACH SEATED ON CHAIRS,
SURROUNDED BY POTS AND PANS AND OTHER
THINGS NEEDED FOR THE STAY.
WHEN WE ARRIVED AT THE FARM, HOPPERS
PREPARED THEIR HUTS TO MAKE THEM
~~LIVEABLE~~ HABITABLE.
MY NAN'S MUM WENT HOPPING IN THE 19TH
CENTURY TO A PLACE CALLED BARMING IN KENT.
MANUAL HOP PICKING ENDED AT MOST FARMS IN
THE EARLY 1960'S. WHEN MACHINE PICKING CAME IN.

Year/Approx: 1948 – 1960

Hop farm: NEW BARN FARM. YALDING, KENT

Do you know others?

could play in fresh air, all added to this general feeling of freedom and salubriousness of the experience. The 'Hopping Afternoons' therefore create a backdrop against which to articulate and explore this culture, the mobilities within urban communities and the close connections they have with the countryside. They also call attention to both economic and social interdependencies between urban communities and rural conditions.

Another key activity within the project is a current version of 'going picking', which includes local urban foraging, gleaning and harvesting from commercial farms in Kent and Essex, for fruits, berries, flowers and other plants to use as ingredients in the new **Company** drinks ranges. The picking follows the seasons and drinks ingredients gathered so far range from birch sap in early March to spring plants, elderflower, limeflower, strawberries, wild plums, blackcurrants, blackberries, pears, crab apple, grapes, elderberries, rosehip, rosemary and other herbs as well as surplus fruit from local farms and hops from Kent. Picking trips vary in form and purpose. They can be informal drop-in foraging walks in local parks or more organized sessions with local schools and training colleges as part of their school curriculum. Then there are the bigger coach-trips – for example to go hop picking in Kent, or gleaning at a working fruit farm after the blackcurrant harvest has happened.

Rather than seeing itself as a catalyst for action within the community, **Company** sets itself up as a suggestion or an invitation to people to do something together – in a different manner to many other offers – on the basis of shared interest. In bringing a group together, the aim is to investigate what can be shared and co-produced, and explore ideas for the potential of local beverage production using common resources taken from civic land. Within this space, activities that might have been long forgotten can be rehabilitated. Activities can be seen both as ends in themselves, and in a wider sense as a laying of foundations, skills and interest in, and for, the future collective beverage enterprise.

Rural and Urban: Socialities of Dependence

The project raises a number of important issues that address relationships between the urban and the rural, and the role of the artwork in relation to them both. Rural and urban living conditions have always been mediated by hugely varied and increasingly complex technologies. The diverse and differing forms of technologization of urban life and rural production seem to have resulted in the two conditions apparently existing in a state of inexorable separation, driven apart by polarized relationships to notions of land, nature, resources and types of production that take place.

This increased technologization of living and working circumstances can be contrasted by the rise in urban gardening and small-scale agriculture and

craft-based alimentary production. For example, endeavours like east London based Growing Communities5 address the feasibility and efficiency of urban food production in areas like Greater London through initiating community-based infrastructures that support small food producers through local markets and vegetable distribution schemes.6

But what do we mean when we talk of the urban and rural here? As ever-greater numbers of people around the world choose, or are forced by economic necessity to inhabit urban conglomerations, rural conditions seem to be something to be left behind, forgotten about and excluded from the urban. In its proposition, **Company** is reminding us that this is of course an imagined separation and a clear split is not the case. The artwork puts forward the idea that rural and urban conditions are inherently connected in multiple ways, tracing lines of enquiry through and across this imagined juncture between urban and rural conditions. Indeed it is important to note that while the Becontree Estate was built on former farmland, the local country park and pebble pit, which have all the appearance of a pre-existing rurality, are the result of the development of this large-scale residential estate, the result of its construction.

It is not therefore the case of bringing the two sets of conditions together, but instead unpicking and analysing existing connections and suggesting new ones. Notions of the rural are revived therefore as being part of continually intersecting engagements that bring multiple human activities to bear on social and economic potentials of what we might call 'natural' entities within urban environments. This is borne out by permeating urban locations with rural processes, as far as specific local conditions allow. In doing so, **Company** raises questions about what it means to be engaged in rural production processes, what kind of land resources are required and how such processes can be altered and shifted to create a new economic cycle within an urban setting.

The frameworks defined by **Company** are founded on conditions informed by historical and social narratives. Its starting point is a shared history of an urban working class community engaging in rural production. The project raises what Foucault calls 'subjugated knowledge' – a set of knowledge 'insufficiently elaborated'7 or in another way, it creates social situations that generate knowledge around a set of subjectivities not normally taken into account within the economic cycle of production, namely the British working class living in the south east of England in the late nineteenth and early twentieth centuries. Rejuvenating this history might challenge dominant histories of rural production, or at least unsettle existing power relations already sketched in rural histories. In the case of the Becontree Estate in Dagenham, the project's lines of enquiry highlight a wide network of connections that follow the changes in land use

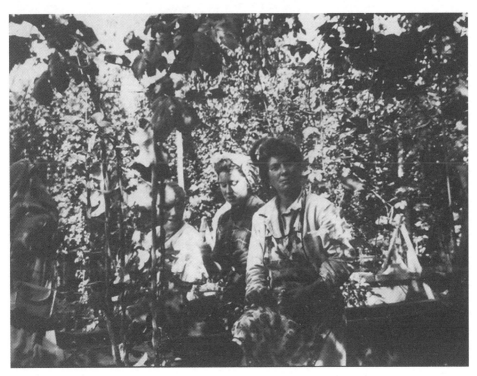

Mother Ellen Reid in the hop garden.
Photo courtesy of Maureen Hostler.

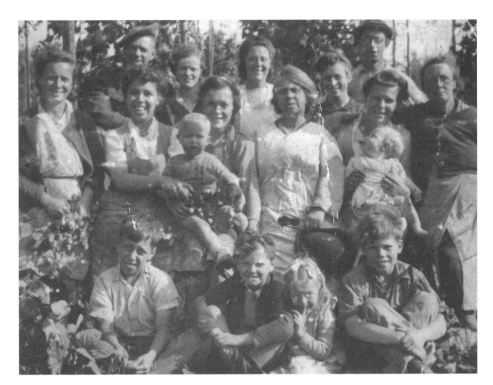

Mum, Nan and other family members, 1942.
Photo courtesy of Evelyn Hazard.

and movements of communities living in south east England. It describes many changes and transformations: the annual movement of east London communities to the hopping gardens of Kent; the more permanent movement of some of these communities to the new houses in the estate; the shift in land use in Dagenham, from farmland and market garden to a London County Council housing estate and industrial zone, with the opening of factories like Ford Dagenham and R. White's Lemonade; to its current situation where manufacturing has declined and many of the former council houses are now in private ownership. The artwork foregrounds these histories, and produces new social arrangements through both knowledge and goods production. Urban and rural histories here work in tandem.

Art, Collaboration and Publicness

The combination of its two propositions – history and socio-economic activities – founds the artwork on a complex set of conditions that are further complicated by the spaces within which it takes place. Where are these social interactions happening and what does this mean for the position of the artwork? The artwork's activities take place in what can be understood as a public sphere – a civic space designated for the use of the community – which can be understood as spaces to which citizens have 'free' access, and equally the project is open to all members of the local community. However, this apparent freedom is set against the reality of the fiction of public space. While the notion of the public sphere might appear to propose spaces that allow free access for all sections of the population, in reality this is rarely the case. What constitutes public space and who constitutes the publics that can use it are always contested. The notion of the public is also intrinsically bound to the notion of the private, and this reminds us that both public and private spaces are always instituted through political arrangements. But the public sphere must also be acknowledged here through its regulation as such with its own boundaries within which public activities can take place, according to the bylaws of the civic authority. The activities and workshops that take place as part of **Company** happen within this context of what outlines a public space, and in so doing help to broker new possibilities as to what kinds of activities can be carried out in this space. The process of the artwork arranging and rearranging the possibilities of what can be carried out within a public space maintains the tension of the 'publicness' of the space. As Doreen Massey says, 'the very fact that [public spaces] are necessarily negotiated, sometimes riven with antagonism, always contoured through the playing out of unequal social relations, is what renders them genuinely public.'8

The project also engages with ideas about the social by the fact that it is constituted through social activities. By engaging with knowledge, histories, production methods, products and contexts the artwork emerges out of the many different openings through which participants can engage with it.

Helpful in understanding how a notion of the social operates here is Claude Lefort's idea of the social that he outlines in his essay 'The Question of Democracy' as being defined as 'designating modes of relations between groups or classes'. His notion refers to the 'space that is designated as society'9 but does so through examining ways in which the systems and relations which take place there are formed. So the social is not solely constituted through any distinct domain or materiality. The events and workshops that form the structure of **Company** can be defined therefore through the groups of individuals and entities engaged in continually shifting activities. Their sociality is by nature both dialogic and situated, but it is also fluid and intersects across boundaries.

Reviving a history of the hop picking alongside the gatherings taking place in the local community also generates new sets of circumstances that intervene in existing socio-political structures, through interventions that philosopher Jacques Rancière might call 'dissensual'.10 The interventions of **Company** happen in the spaces and activities of the project, both imaginary and real, through the establishment of histories, stories and organizations. What the project therefore proposes are new cultural definitions of specific public spheres. Importantly however, the project does not create or propose new identities for a generic space of the public as such, or institute a version of a generic space, but rather instigates particular space-time circumstances that allow possibilities for structural transformation of that space to be imagined. The meeting places of socialities become points at which new socialities are framed.

However, there is another space to consider here. These meeting places do not have to be space-specific, and socialities produced by groups of people can be seen as part of a non place-specific public 'connective realm' constituted of spaces where different narratives meet and become hooked or equally unhooked at points of intersection. The idea of this space will be explored in more detail further on in this book, but for now it can be understood as a space beyond the physicality of a site and its accessibility, and one that cannot be conceived in its totality, but rather one that operates to connect individuals within wider or new networks creating bridges between the individual and the societal.

Objects as Actors

There is also what we might call non-human participants in this project: the natural entities that are foraged and picked, the drinks produced. How can we think through these participants as being part of the social and what does this contribute to an understanding of the project's critical potential? It's helpful here to outline the shifting pattern of associations that occur around the drinks within the project. Their ingredients are extracted from traceable sources; they are produced by accountable groups and traded for and within particular situations. As such, they do not become alienated or abstracted from their

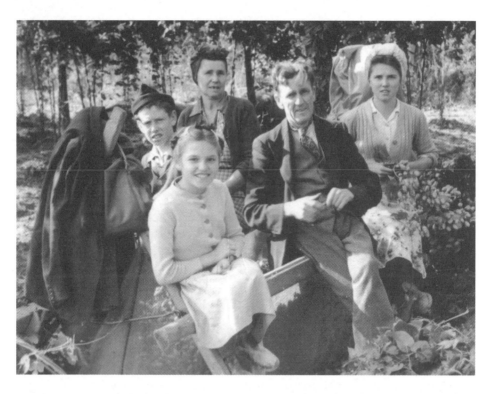

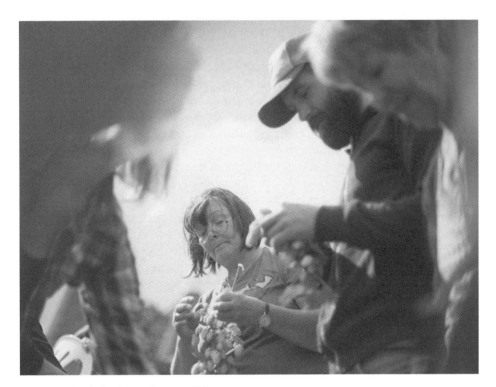

Left top: Family at the hop bin, Tipples Farm, 1950ies.
Photo courtesy of George Laden and Shirley Smith.

Left bottom: Photo collection, *Hopping Afternoons.*

Right: At the hop bin during the 2014 hop picking
trip, with former pickers from Barking and Dagenham
and brewers from Kernel Brewery.

production process and origins and point of trade. As resources for the drinks, the berries and flowers foraged for on the local civic land cannot therefore simply be reduced to the status of nature, or resources, or even natural resources. Integrated into wider social activity, and part of a new community they have a social presence of their own; they are integral to the dynamics of the project as social objects. As Bruno Latour says: 'As soon as we allow [non-human objects] to enter the collective in the form of new entities with uncertain boundaries, entities that hesitate, quake and induce perplexity, it is not hard to see that we can grant them the designation of actors.'[11]

Hence these objects, brought into the workshops and production processes of **Company**, whether they are the hops of hopping histories, or fruit and flowers from local lands, all become actors within the collective activities of the community. In this account they become mediators in their own right – through knowledge of how to use them for the purpose of making drinks, through their histories and through their cultural associations. One way of framing the berries and fruit within the social spaces of the project is by thinking of the project activities as acts of scripting their potential along with that of the related, human actors. Scripting here can be thought of in terms of Latour's schema of producing descriptions of the agency that the objects have on other objects or on humans through various means.[12] Integrating the objects into the social activities of the project as actors allows for a tracing of the connections and associations between the objects and draws the contours of their socio-politics both within the project and outside of it. This strategy becomes a useful tool in thinking through how alternative organizations of the elements within production processes might be configured. The concept of scripting can also help to think through the project's broader parameters. It might mean setting out a diverse and varying proposal within which the possibilities for the project can be outlined, along with varying ways of integrating the many elements connected into the structure of the project.

Scripted Associations

Such a proposal would have to account for more than just the social dynamics in which the physical elements become embroiled. And in this context there is already one designated scripting of the project: the aim of setting up a social enterprise. The endeavour is aiming to extend the cultural and economic boundaries of the artwork, to produce something that exists beyond the boundaries of the artwork, in which participants become the stakeholders, while at the same time retaining its status as artwork. The evolution of the project into an economic configuration does not uncouple it from its artistic status, giving it an aesthetic-economic duality. Hence the artwork doesn't 'end' as such and does not focus itself solely on an economic pursuit. It aims instead to initiate a new kind of shared practice that produces a tension between its parallel cultural and economic status.

Maintaining the artwork's status serves as a continuous reminder of the artificiality of the artwork. Artificial is not used here in the sense of it being fake or insincere, but rather in the sense that it has not emerged out of dominant, accepted socio-economic protocols and structures. Rather, it evolves out of alternatives. By doing so the artwork is able to maintain its questioning of dominant economic models by setting up cycles and purposes for production and trade that are rooted in the social and cultural rather than the economic. The art here becomes part of 'business as usual' for the enterprise itself. This also opens up broader questions around the relationship between art and what could be called the practice of living. How can the artwork operate within existing social settings and take on some of their structures? The artwork survives here through its continuous return to the cultural within which its structures are situated.

There is a process of communal discovery taking place as the project's activities progress and build on each other. What the artwork uncovers therefore is the fact that relationships between the rural and urban are always in construction, are always in the process of being made. In **Company** they are depicted as porous, with this porosity being harnessed as a way of renegotiating modifications within civic life. This opens up numerous starting points for discussions around the operation of alternative economies, in whose interests they operate, and what kind of possibilities they present for reshaping our cultural, social and economic topologies.

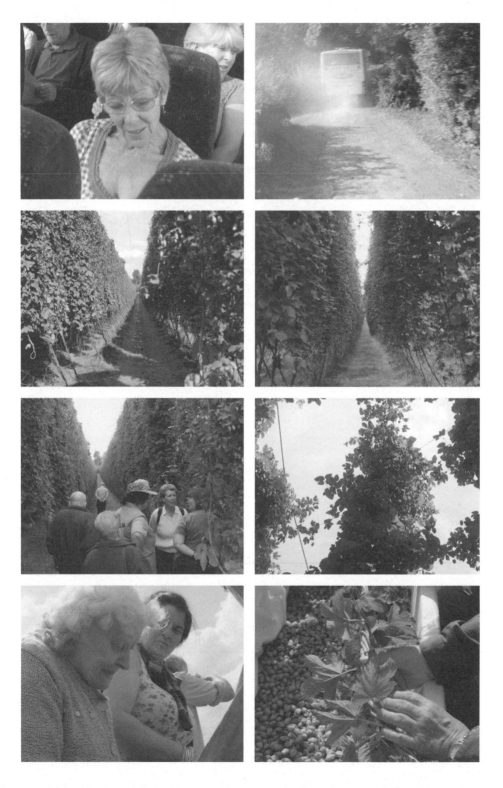

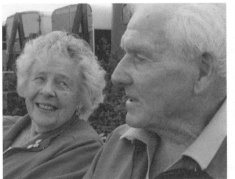

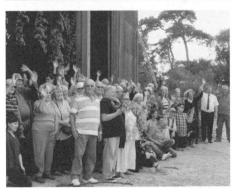

Stills from the Company hop picking trip to Ian Strang's Little Scotney Farm, Lamberhust, Kent, September 2014. Film by Jake Powell.

NOTES

1
Dagenham and Barking is officially known as the London Borough of Barking and Dagenham and it is located on the outskirts of east London. Once part of the county of Essex, it was incorporated as a borough of London in 1965. Before urbanization and industrialization, the area was countryside and market gardens for London and Essex. http://en.wikipedia.org/wiki/Dagenham [accessed 06-09-14].

2
In the nineteenth century, hops were widely grown across Kent, and at its height between the 1920s and 1950s the annual hop pickers from London would total around 250,000, transported on 'hopping special' trains from London Bridge Station. Cheaper, imported crops led to its decline and today hop gardens take up less than 3,000 acres. All but one hop harvest has been mechanized.

3
Valence House is one of two surviving manor houses in the area. It is a local history museum and archive. More information can be found at http://en.wikipedia.org/wiki/Valence_House_Museum and http://www.lbbd.gov.uk/MuseumsAndHeritage/ValenceHouseMuseum/Pages/Home.aspx [accessed 06-09-14].

4
It's worth noting that it was mainly women and children who took part in the hop picking, while working men often stayed at home during the week to continue their jobs, visiting their families at the weekends.

5
Growing Communities is a community led enterprise in east London that provides alternative food growing, trading and purchasing opportunities for local people and food producers. More information at http://www.growingcommunities.org.

6
For a broader discussion of the issues relating to small-scale enterprise see Greg Sharzer, **No Local: Why Small-Scale Alternatives Won't Change The World** (London: Zero, 2012).

7
Michel Foucault, **Power/Knowledge – Selected Interviews and Other Writings 1972–1977**, ed. Colin Gordon (Brighton: Harvester Press, 1980) p. 82.

8
Doreen Massey, **For Space** (London: Sage, 2005) p. 153.

9
Claude Lefort, **Democracy and Political Theory** (Minneapolis, MN: University of Minnesota Press, 1988) p. 11.

10
Jacques Rancière, **Dissensus**, trans. Stephen Corcoran (London & New York: Continuum, 2010).

11
Bruno Latour, **Politics of Nature: How to Bring the Sciences into Democracy** (Cambridge, MA: Harvard University Press, 2007) p. 63.

12
Bruno Latour, **Reassembling the Social: An Introduction to Actor-Network Theory** (Oxford: Oxford University Press, 2005) p. 79.

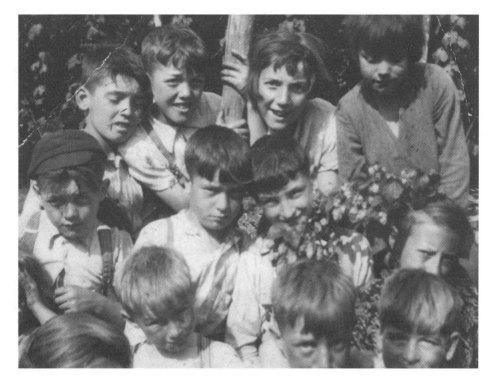

Children of the family related to Evelyn Hazard.
Photo courtesy of Evelyn Hazard.

THE WOMEN AND WHY THEY PICKED

This is a reprint of chapter one from
Gilda O'Neill's **Lost Voices** book, first published
by Arrow Books in 2006, Random House,
London, UK. The book records the memories
of East End women who went hop picking
in the past.

Gilda O'Neill

'You didn't see a lot of wildlife in Canning Town.'

> The things that stand out were the company and the enjoyment on
> the field. The atmosphere on the field was always happy. There never
> seemed to be misery. There was always a happy atmosphere there.
> I thought it was good. You got away from London, had a breath of fresh
> air for the children, built them up. You got a bit of money at the end.
> We sort of saved up before we went. We got our food ready, our tins
> of food. And it didn't really cost us a lot. But what money we earned
> hop picking, we might come home with a bit! Mrs M

There is no single reason why so many London women went to Kent as casual
agricultural labourers during the hop harvest. There is no single answer
to why they were prepared to suffer the hardships and deprivations of living
in hoppers' huts. As Mrs M begins to explain above, the reasons were varied,
overlapping and often contradictory. Chapter 1 looks at some of the reasons
the women themselves give for why they went hopping. But as will be seen
later, the reasons for the yearly migration to Kent changed, as did the hop
harvest, the women and their lives.

Whether the women saw picking as a holiday or as paid work depended
partly on their financial circumstances, but also on their skill and speed
as pickers. The following comment was made by Mrs D, a woman who saw
hopping as part of the yearly cycle of agricultural work to which she and
her family were tied:

> You see now, I'd go hopping, do a bit of fruiting. Time I'd done
> hopping and one thing and another – I could pick hops – so that
> I'd come home with a nice few bob saved up for Christmas. That's
> how I used to do it ... I used to pick 60 bushels of hops a day, on
> my own, see? ... I always had a bin on my own. There you are, that's
> my old hopping book there. That's how many hops I used to pick!
> Sixty, sixty-four a day. I was good at it ... I was very quick. Good with
> my hands. Mrs D

Mrs D was a fast picker, exceptional in fact, and as a representative of English
Hops Ltd agreed, it was not sensible to go hopping for 'big money' unless
you had such skill.

The need for money to buy special things for Christmas, finding extra shillings
for specific items like winter coats, or simply to meet a surprisingly big bill,
were all mentioned by women as being important reasons for going hopping.
What might be considered luxuries at other times of the year could effectively
become necessities at Christmas time.

Mrs S I used to put the hopping money away for Christmas for the kids' toys and new clothes and that.

Mrs C When we were kids that's what my mum used to do. It would clear her debts and loans...

Mrs S Money for the tallyman! Like old whatshisname down Burdett Road.

Mrs ML That was the only way I got my school uniform, mum picking hops.

Mrs C And we'd all have a new velvet dress, Christmas – out of the hopping money. 'You don't pick', she'd say, 'and you don't get no new dress.' You had to work like bloody hell to get that velvet dress.

Not all the women who went hopping specifically to earn money did so to pay for extras, or because their skill made it worthwhile. Some women went because they had little choice or opportunity of finding alternative waged work.

Mrs AA used to go to Kent with her grandmother, aunts and cousins:

My family had to pick for the money. They were poor. They'd have to make the kids pick. My nan needed the money. There was 13 kids in the family ... She obviously went for the money, but it was a break as well from life in London. But the money came first. It was a way of earning a wage with all the kids. I don't think she could have done that in London. See there was so many kids. What work could you do with all them around you? You could work, see, and keep an eye on us. And everybody, all of us, earned our own little bits ... see, me nan went primarily for the money. She had to. Me grandad drank most of his money away. It was hard work for me nan. She'd have a laugh but it was hard work. She used to have to earn her money. It was different for other women and kids. But see even though it was hard graft and she needed the money, it was her break. It meant a real lot to her. She got knocked around by me grandad – drink again, it's always drinking. We used to see a lot of it. So getting away down hopping was something to look forward to. It was a break away from him. It was a different way of life.

The significance of hopping being a job where the women could take their children is looked at in more detail later in the book. But it wasn't just 'childcare provision' that mattered to the women, they also acknowledged how important

it was that the elderly, the less able, very young babies and even household pets, could all be taken hopping. Most of the women remembered this as a particular perk, which helped to make their lives easier. Mrs C (who cleaned the Mansion House steps on her knees every weekday morning and two evenings, using just soapy water and a scrubbing brush), pointed out that in London many of the women found it necessary but hard to leave their children at home, often still asleep, while they went out to work.

> You could have your children with you down hopping. Not like the cleaning work I had in London … That was hard. Mrs C

> All of us went. Nan, kids, aunts, cousins. We used to take the horse. We even took the goldfinches in their cage! Mrs D

It was not only the relief, and convenience, of being able to keep her child with her that Mrs M remembered. Hopping was also a 'treat'. She and her in-laws went because:

> That was their summer holiday … I used to go when Aunt F was down there … I used to look forward to the holiday.

Mrs S, on the other hand, thought that her in-laws emphasized the holiday aspect of hopping to show that they did not have to go for the money.

> They thought they were a bit posh. They used to make a fuss about it being a holiday – to prove they were comfortable! It was no good us pretending. Our mum had to do it for the money. Mrs S

Earning some money to take home at the end of the season did not seem to be an issue for some of the pickers. For instance, Mrs J, who used to go hopping as a girl, and now has the tenancy of a pub next to a hop farm, made the following observation about some of her hopping customers:

> I don't know how they earned any money out of it, all the money they earned was all spent on beer anyway!

Mrs RR's aunt was a businesswoman who 'had money', but still went hopping for her holidays even though she could have afforded something different.

> My old Aunt H had money. She owned a florist in the old market and still always used to go hopping. Still went. She had a few bob. My mum used to work for her. That good business and she still went hopping … definitely didn't go hopping for the money. I mean, even the jewellery

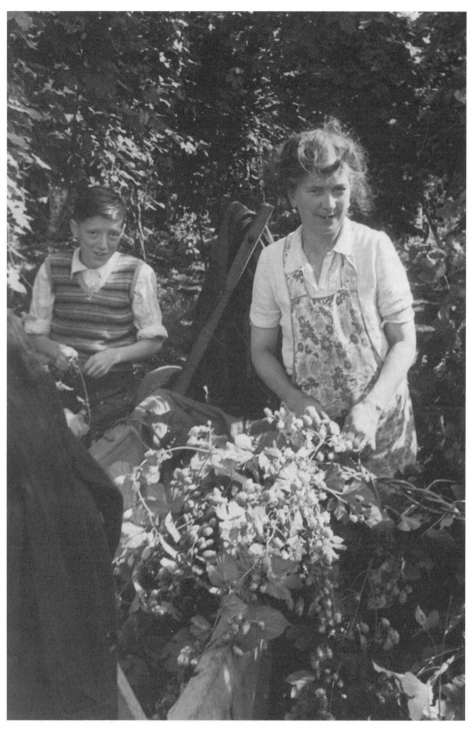

Mother Ellen and brother Terry, 1949.
Photo courtesy of Maureen Hostler.

she left. You know it was only in the latter years that she bothered
to go abroad ... it was always hopping ... go down there for a month
or more and come home every Wednesday to have a sauna down
the East Ham Baths!

Mrs RR's aunt had another reason for going hopping, one that she shared with
other women I spoke to. For Aunt H, hopping wasn't just a holiday, it was also
a legitimate reason to be away from her husband.

See for years my Aunt H and Uncle C, well, they never got on. And,
er, I think, er, he had another woman. You know ... It wasn't very good,
all that. Mrs RR

Mrs AA's grandmother had similar problems.

I love my nan. I can sit and listen to her stories forever. I get choked ... See even
though it was hard graft and she needed the money, it was her break. It meant
a real lot to her. She got knocked round a bit by my grandad. Drink again.
It's always drinking. We used to see a lot of it. [Pause] So, getting away down
hopping was something to look forward to. It was a break away from him to
a different way of life. The mud puddles with your wellies. Mostly nice weather!
Few wet days when all the water'd run up your arms from the bines. But you
imagine, in the pissing down – oops! – the pouring down of rain [laughter] and
someone starts a conversation, or a song. Imagine it! Kids all in the mud with
their wellies.

Wouldn't have to worry. [Pause] 'Roll Out the Barrel.' And all that!

Even the women who had no money to spare, and who might have
to find some extra cash to go hopping, would still be glad to get to Kent
for the harvest.

G Was it the holiday or the money that was important?

Mrs C Holiday. Because you couldn't afford a holiday otherwise.
Don't know about you.

Mrs S We never had no holiday, never. Apart from hopping.

Mrs C That was ours. That was ours.

Mrs ML We used to ask, 'What's for dinner?', and mum'd [Mrs C]
say, 'I'll see what I can afford.' And we had something, but holiday ...
Only holiday we ever had.

G So, could you earn?

Mrs C No, not there. Not there. [The particular farm that they went to.] Well, I never did, and my mother never did, because it was a working farm where you had to pick so many hops. You know, to earn sort of, well, you couldn't even earn a pound a day. And, er, well I think to myself: it was a hard way of living, for what you earned for what you done. And the hours you put at it. Yes!

G Could you earn more at home, in London?

Mrs C Yes, but here you'd have your holiday, and your children with you. Actually you was taking a cut in your money. It cost you more to live down there – you know it do ... But, of course, you've still got to remember the rate of money then. See? I had to save up to come down hopping.

G You had to save up to go hopping?

Mrs C Yes. But in London, I'll tell you the truth. I did cleaning in the Mansion House. Twenty-five bob a week and go back twice a week on an evening. Know what I used to do in the Mansion House? Clean them bloody steps outside. That was my job. Yes.

G You didn't? With little ones? What hard work. What times did you have to do?

Mrs C Six. Our time was six in the morning till nine. Then twice a week we used to go back. Twenty-five shillings for that.

G Hopping must've seemed a doddle!

If women like Mrs A's grandmother were getting away from drunken men – for the hop harvest at least – others, like Mrs C, were getting away from the hardships of city life. With the development of modem transport systems and the increase in private car ownership, the hop gardens now seem much nearer to east London, but during the war years they could have been in another world. This was particularly true in those years when the East End was being bombarded during the Blitz. By going to Kent the women and their children could escape the horrors of the air raids, which affected so many London families, killing loved ones and destroying their homes. Later, when the war was over, they could temporarily escape the housing shortage, which, for many of them, meant living in cramped, sub-standard conditions, billeted on neighbours or family. Mrs M talked about many benefits of living the country life.

It was different hours, different environment. You got away from it – London. You got away from that being 'cramped in' in London. Once you got out in the fields it was so different. When you was in London, you was squashed in. That's how it seems to me. People. You was all free down hopping. Relaxed. If you went to Southend you was lucky. Even when we went to Loughton for the day, from the mission, that was wonderful. This was further away, and we stayed there! It was beautiful … During the war, especially, we decided to go down to get away from London, if you know what I mean … that's when we took R [her daughter]. It was Mr M's family what actually did it [the picking]. I went for the break. To get away from the raids.

The Kent countryside did not escape the bombs entirely. Mr D, a hop farmer, provided a rural version of the air raid shelter for the pickers.

Mr D We had a plane come down here! We had one crash in the hop garden when we was picking! That caused a scene. The bloke who crashed in the hop garden, by the time we got him out, was dead. That was a Messerschmitt 109. We had a big dyke dug up there – soon as the warnings went they used to stand down in it. Below ground. And when the all clear went they'd go back out on the bins.

G Did you have much trouble round here?

Mr D See, we had the worst day. About eight raids that day.

G Not so bad as London with the Blitz then?

Mr D Oh yeh! I mean the only time they dropped their bombs here was when they got shot or tried to get back. Otherwise they'd carry on to London, obviously. See?

It was not just violent men – whether husbands or bombers – that the women were glad to leave behind. Many of the women's recollections were from the days before smokeless zones were introduced, making the contrast between the Kent countryside and inner London even more vivid. Going hopping was as much about the desire to leave the choking atmosphere of the polluted city (if only for a while) as it was about the draw of working in the greenery of the hop fields, even if the source of the greenery was sometimes a little surprising for town dwellers.

Mrs T You know how you used to walk through the fields after you'd finished picking one? You'd have to move through that field to the next one. I'll never forget one morning when I got up. I'd never experienced

GILDA O'NEILL

Mother at Spring Farm, Kent.
Photo courtesy of Teresa Dimech and Raymond Brown.

anything like it. There was all these people walking across to the next field and I like saw these, a big line of green things. All hopping! And I said, 'Whatever's that?' And they said they was grasshoppers. Well. Like, as the people were walking through the fields, they was moving. I'll never forget that. Like a long line moving. You didn't see a lot of wildlife in Canning Town!

Mrs R No, the birds never sang there – they coughed!

It wasn't just the birds in Canning Town, the children coughed too. Their mothers looked on the fresh air of the Kent countryside as an important boost to the children's health. Their offspring could be 'built up' and have their lungs 'unclogged' to make them strong enough to withstand the coming winter that brought seasonal ill health and increased child mortality. Kent County Council (KCC), however, were more concerned with the children's possible ill health in the summer. Medical care and other support services for the yearly influx of Londoners meant bigger bills. Instead of seeing the hoppers as the vital source of casual labour which the farmers knew them to be, the local authority viewed the hoppers as potential sources of epidemics and users of costly-services – a threatening 'other' to upset the tranquillity and order of the rural idyll.

Arguments between the Kent and London county councils began and continued. Finally, Kent demanded that the LCC contribute to any additional costs incurred as a result of the Londoners' presence. The debate was particularly bitter about provision for the hoppers' children. The KCC claimed that the children were of no economic value and did not contribute to the harvest, but were in Kent's beautiful countryside for the sake of their health. (This was not that far from the truth in many cases.) London made the counter argument that the women and children would not be there at all had their labour not been needed so badly by the Kent hop growers.

Whether it was the hoppers or the farmers who were the real 'winners' was an official argument, conducted at the level of conferences and public reports, between the county councils. Superficially, at least, the women's experiences and memories seem to support Kent's belief that it was the Londoners who came out best. Mrs AB told the following story:

Pound and half born! I must've been like a bleeding rabbit, mustn't I? And my mum said hopping was the making of me. I was born in April, see, and I wasn't getting on very well. I was born indoors. And one of the neighbours – Aunt Ginny as we used to call her, another adopted aunt! – said to my mum, 'Bring her down hopping.' She'd been down hopping for years, you see. And my mum said, 'No, it'll kill her.' My mum hadn't been before. She said, 'Course it won't. You bring her down.'

So mum took me and the three youngest boys. Aunt Ginny wrote to the farmer and said she wanted another bin, was it all right? And they wrote back and said yes it was, so we had a hut for ourselves and a bin. And as I say when we went back I was twice the size I'd been before I went. Four and half pounds when I went back from hopping. Born a pound and half. And I went every year after that. And whatever job I had, my mum used to make me pack it up. Yeh, to come hopping, 'cos she said it was the making of me. Well a lot of them used to come just to earn money, but a lot of them didn't. My mum used to come 'cos she said it built you up for the winter. All the bad fogs you got in London, the kids'd get chesty and that.

Yet KCC appears to have deliberately understated the importance of the vast numbers of pickers required each year for the harvest. As the LCC pointed out, without the Londoners, there would have been no harvest. They also reinforced the point made by Mrs AB above, that many gave up their regular jobs to do casual work in the hop fields. Farmer D's memories could be used to support either side of the argument.

I mean, they used to come away and they'd have to give their jobs up. Otherwise the children never got out of London at all, did they? They used to come down here and it'd be three or four days before they finished choking, time they'd got all the soot off their lungs. And them days, course, when they used to get the smogs and fogs. I been up there and when you blow your nose, it's black ... people'd be walking around with scarves round their faces ... you don't hear of fogs in London now ... But those days they used to be. Well a lot of the pickers used to come down Easter and wouldn't go back till after hop picking. Stay right through the season. Strawberry picking, currant picking, whatever there was going.

The local authorities had concerns other than the health – or lack of it – of the pickers' children. They were also concerned with their school attendance – or lack of it. How the pickers viewed the annual break in their, or their children's education depended on their view of the schools and the relative importance to them of going hopping. Mrs A, one of the younger informants, had strong views on missing school.

I think in the London schools they used to take it for granted. I think so, you know. It was the done thing for so many kids anyway. Mind you I was never really at school anyway. Always used to have the truant officer round! I was always on the hop! Wonder if that's where it comes from? 'On the hop' 'cos of going down hopping? As a kid then I'd really look forward to getting away down to hopping.

Left: In front of the hoppers' huts.
Photo courtesy of Violet Charlton.

Rose Wright (mother), picking.
Photo courtesy of Rose Wright.

The idea that missing school did not matter too much if you were a Londoner was also held by Mrs D, who missed school every year. When she became a mother her own children did the same, and it was her turn to take them, as their grandmother had taken her.

Mrs D They never used to take no notice then. Everybody did it then, didn't they? I should think schools could have shut up when it was hopping time. Round our way.

G How about the local school board man? Did he used to go to the fields looking for the local Kent kids?

Mrs D That's right, yeh. He was always looking for them. But no one used to take no notice of us, did they, coming from London. Our mum and dad had us all ready on the Monday we went home. We was all washed and polished. Take a note to tell 'em you'd been hopping. And er, just go back in school. And we used to stop there all winter, you know. Yeh, we used to go to school regular, every winter. Never in the summer.

Sending in a 'note' was quite usual but not all the notes explained where the children had actually been.

Mrs C I'd send a letter in. That was it. They'd gone on their annual holiday. I never said 'hop picking'. Annual holiday.

Mrs M Lot of them said, 'We're going down the chalet!' Not hopping.

Mrs C Yeh. Not the hop hut. [Mock posh voice] 'The chalet.'

Mrs T's mother didn't have the opportunity to send her note. The 'school board man' came to the house while her daughter was away hopping with a friend's family.

My mother said to the school board man when he came, 'Oh! she's gone away with her auntie to Ilfracombe in Devon.' And he said, 'What a lucky little girl!' [Laughing] I never even seen Devon! I'd never even been down Southend, let alone Devon.

Other women didn't see any point in making excuses; their families had little choice about going hopping. As Mrs AB explained:

We used tell 'em they'd be away. Wasn't much they could do. There were so many kids would be away. Most of the really poor kids had

to go. For the money, for their health and that. No, the schools couldn't do nothing, could they?

Farmer D, as an employer of hop pickers, was affected only marginally by the children missing their education.

> Well, in them days, it was no problem. But after the war, like now, if they want to come down here they just report. And you know I have no bother. We used to have forms at one time. The farmers would have to sign it and they was all right – to say the family was working hop picking. Oh special forms we used to sign.

Whether the children would have missed even more school due to ill health is something, which can only be guessed at. What is certain is that going hopping was too important in their lives for a little thing like the school board to stop them. Their feelings about the work and what the experience meant to the hoppers were puzzled over by Mrs R and Mrs T.

> Mrs R It was just a thing you did. It was more a holiday than anything else for us. Never had a holiday, did we? Well we never did …

> Mrs T We was exploited really. All for a pittance we earned, didn't we?

> Mrs R And when you think about our conditions! We was exploited … and it rained solid for a fortnight … well after a fortnight they'd had enough. Couldn't pick, couldn't do nothing. And that's all they'd gone down there for wasn't it? A bit of bun money wasn't it? Money for luxuries … They used to have to work hard, and not for that much.

When they tallied at the end of each day [worked out the day's earnings], you'd never get that much down on your card. Plenty of them had nothing to start with. They'd have a sub almost as soon as they got down there … But then I think we really enjoyed it. I did. I did enjoy it.

> Mrs T But when you think of it these days. It was a working holiday, wasn't it? It wasn't much of holiday for adults really I suppose. But it was for the younger ones.

> Mrs R I don't know the reasons they still go [her cousins who still work on a mechanized farm]. They don't need the money. My C still goes down to them for weekends. It's just like having a chalet I suppose. See it's what you've always classed as your holiday. Even though sometimes it was a bit rough, it was your holiday.

And as Mrs AA said:

> I don't know how they even knew [about particular farms but I suppose
> it was in the family before them]. It's always been there. Like me, I first
> got to know of it 'cos I was always taken. To me it was the expected thing,
> at a certain time of the year, to go hopping.

INFRA-
STRUCTURE

Céline Condorelli

With infrastructure something both huge and hidden is conjured up, a dark and indistinct shadow of a thing, that imperatively needs to function for it not to be thought about. Conceptually always beneath structure, below architecture, under life as we know it, the infra is lower in position, in value, it is spatially further, and always to be discussed later.

With such a subservient status infrastructure is what allows society to hold its shape – its structure – as a complex set of events to form and support a stable pattern. The pattern consists of actions, not things, as the universe is constantly moving, and therefore infrastructure needs to re-generate, to evolve, to contain, to transport, to transfer, to guide and generally to move things along.

Infrastructure is often confused with public works, and the local government departments responsible for the planning and maintenance of the practical aspects of city services. And yet it is – as is often the case – precisely within this subordinate function, how it is being imagined and constructed, that is the repository of political and cultural imagination, the network for social and economic connections, and the form of human ecology; in short, infrastructure displays a society's inherent ideology and the conditions that allow or restrict what appears in the domain of the visible (which does not only designate images, but that which is intelligible).

Systems of domination, subjection or repression also take place in the infrastructural, so that it is not simply a manifestation or the embodiment of pre-existing systems but an intrinsic part of their configuration. So that infrastructure is both a symbol of permanence and a channeller of flows, it is a collection of built objects as well a set of ideas about modernity.

What is interesting is the long history of the repression of infrastructure from architectural drawing. The modern city was designed to create and maintain the illusion that infrastructure was a utility to be placed out of sight and separated from the landscapes of our everyday lives. The analysis of the built environment is always to show the complicity with all the supplementary machines, mechanisms and infrastructures, yet buildings and objects always re-emerge as autonomous: we do not like admitting that things have conditions. Left out of the plan, infrastructure was selectively edited out of the new urban utopia, so that the new residential landscape could resemble a tranquil place for the full development of the modern individual.

In the process we forgot about it, and that it needed to be maintained, updated and funded, but also that it was within infrastructure that societies articulate their political imagination, and guide how they want to live in their cities, in their societies, or as Bucky would have it, on spaceship Earth.

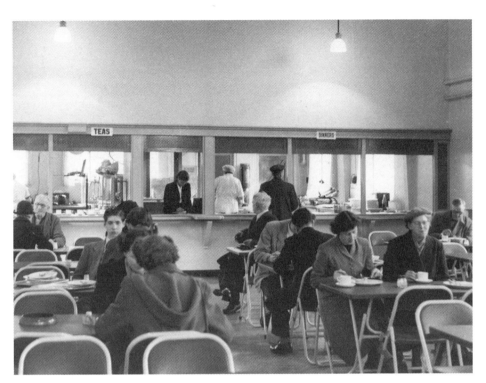

Goresbrook Civic Restaurant looking towards the servery, 1954.

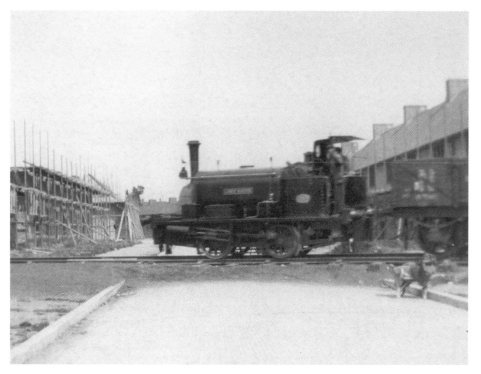

Becontree Estate railway, c.1927.

Woman with a pram on the corner of Rose Lane, 1954.

Ford Factory site before building began.

14 - 5 - 29

MOVEMENTS

Miranda Pope

A Montage of Movements

Movements appear throughout **Company** in various manifestations. They refer to the shifting of physical location in, for example, the movement of communities from London to Kent for hop picking. They also encapsulate ways of thinking about how ideas, stories and politics are carried from one generation to the next and how they change over time – the invisible movements of cultural transfer. Movements also occur as shifts between art and non-art, where aesthetic boundaries are arranged and re-arranged to articulate the project as a work of art in itself and in relation to other artworks and the social situations it occupies.

The negotiation of these conditions and production of the project's structures happen through activities that connect histories, processes and places. The activities both produce movement, and are produced through various types of movement – of people, memories, histories, goods and ideas – that all happen simultaneously: sometimes reactively, sometimes proactively and sometimes independent of each other. Processes, activities, operations and temporalities relating to the production of history and beverages are both deconstructed and reconstructed as they take place, and this defines the boundaries of the project.

Whatever form a movement takes it always means, as Henri Bergson says, that something is in a state of flux, shifting between points, and 'indivisible'.[1] It is a continuous state where people, things, and ideas transfer through space from one point to another. Central to any form of movement therefore is the fact that it is always defined by its articulation within a specific space and time. Firstly, space always defines, and is defined by, the movement that takes place. Secondly, the time taken for a movement to take place may be comprehended in real time, it may bring together a number of different times on one axis, or it may be recorded over a longer period of time, with many witnesses across this timescale.

This spatio-temporal setting in which movements take place are always based upon political factors. Where, why, and when is the movement happening, by and for whom? The traces, marks, ideas, histories and cultures that result from these movements often remain perceptible long after they have taken place. Movements are the numerous activities that effect shifts between specific points in space and time. In doing so, they outline spheres of experience, while at the same time shifting and re-defining existing spheres. All movements are therefore relational. The understanding of movement as relational here is informed by David Harvey's notion of space as relational, which proposes that: 'there is no such thing as space or time outside of the processes that define them ... Processes do not occur in space but define their own spatial frame'.[2] Movements therefore instigate connections through the events of their

movement, which in turn frame specific spaces that dislodge existing spatio-temporalities. These can rarely, if ever, be defined through single movements. Rather, they are complex conjunctions defined by many movements that criss-cross boundaries of spatio-temporal definition.

Movements in **Company** can be understood as the starting point for activities that investigate and articulate alternative expressions of existing forms of spatio-temporal experience, which in turn shift the positioning of these forms. It does this by exploring motivations and shifting contexts through which the movements take place, or have taken place.

The project is structured by referencing a number of intersecting movements through activities that occur across a number of registers – historical, socio-political, artistic and geographic. These movements are used to create condi-tions for alternative ways to practice production and distribution of goods, ideas, histories and cultures. Through engagement with the project, individuals are able to reposition themselves in relation to collective histories of hop picking and relocation, highlighting the physical movement of people and cultures. They are also able to experiment with socio-economic possibilities presented by their locality, to participate in the moving and altering of resources from Dagenham and its locality, by way of collective community actions, so they can become goods offered for sale. Finally, at the level of the artwork, the project continually moves between and around the boundaries of the notion of the artwork, redefining what is and what is not considered art and the contexts and states they inhabit.

By engaging with, and highlighting different forms of movement, the project has the potential to demarcate new spaces, to enact what philosopher Jacques Rancière calls a reframing 'of the division of forms of experience'.[3] Such a reframing takes place by re-routing normative movements within the production of history and beverages, relocating participating individuals in relation to the original movement.

The activities within the project therefore construct, in effect, a montage of movements, framed by the broader social ambitions of the project. The term montage is used here as a tool to understand the effect of the collation of the activities of the project. It also refers to the ways in which all the project's activities, while contributing to the project as a whole, also each have their own ontologies, practices and histories that are transformed into specific forms of experience within **Company.** The activities within the project appear as fragments of broader activities both separated from, and connected to, their origins.

But what are the effects of this montage of movement, and how do the move-ments operate within the project? And what does this mean for the work of art?

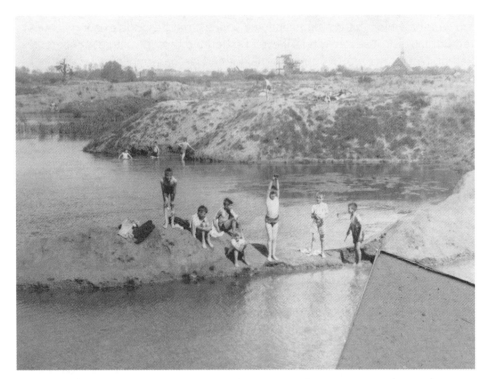

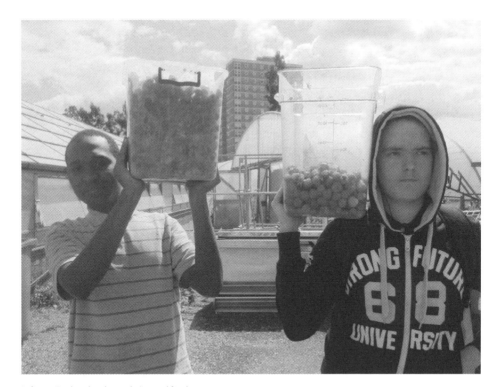

Left top: Eastbrookend gravel pits used for the construction of the Becontree Estate (now Eastbrookend Country Park), 1939.

Left bottom: Going elderflower and strawberry picking with students from Eastbrookend Comprehensive at Growing Communities Dagenham Farm, May 2014.

Right: Picking strawberries with hospitality students from Barking and Dagenham College, Growing Communities Dagenham Farm, June 2015.

To unpick these questions I will look at how different types of movement operate in the project, beginning with the physical movements motivated by questions of economy and which have shaped the culture that is being remembered here. I will then look at the 'invisible' movements that constitute the cultural, historical and socio-political structures of the project. I will then briefly look at current social movements and how their activities are reflected in the artwork, before concluding with a meditation on how artistic shifts play out in the work, and in the formation of its boundaries and social agency.

Visible Travelling

Journeys of goods between points of distribution or production are mostly invisible or overlooked things to be managed as (cost-) efficiently as possible and not considered important unless things don't go to plan. What usually matters are journeys' ends, the points where the value of the goods that have been in transit can hopefully be realized above and beyond costs accrued so far.

By contrast, focusing on the journeys made by resources as they become goods, and the goods themselves brings their socialities and networks of dependence into a visible space. This allows questions about who is making the journey, why and for whom, to be brought up for discussion. Focusing on the goods as they travel creates conditions where the politics behind the journeys can be revealed, creating a politics of the 'in-between', a politics that highlights the motivations, interests and positioning of those involved in the creation, moving and selling of goods.

Physical movements in **Company** take a number of forms: the physical ground/terrain covered by the participants in the workshops; the journeys taken by the communities who went hop harvesting annually in Kent, and the re-location of communities from east London to the Becontree Estate in Dagenham. Movements also take place in the transfer and distribution of resources and goods used across each element of the project, from field to workshop, from workshop to fair. Finally, the project also encompasses the movement of the cycle of the harvest, and the physical manifestations of the fruit and hops as they grow and ripen. Highlighting these movements reveals their start and end points, their connections and motivations. The framework of the project is built through these connections, as it takes place. Socially negotiated, the connections create interactions that open channels of transaction. These interactions take place in a variety of settings – elder-flower picking, blackcurrant gleaning, on a hop picking trip, at a cola workshop, strawberry picking, or at a business development meeting for example – and are where ideas and knowledge are passed between collaborators.

So what is interesting about **Company** is that final goods are contingent upon and embedded within the sociality around these connections. The goods

become a form of communication about themselves, in themselves, both through their production and distribution with the two sets of conditions existing simultaneously.

This can be seen in relation to other artworks that deal with movements of goods and people, and which also can be seen to be concerned with a politics of the in-between, like Kate Rich's **Feral Trade**4 and Alan Sekula's documentary film **The Forgotten Space**.5 Rich's project sets up a similar process of socially instituted commerce through an international trading business for a number of products including coffee, olive oil and green tea. Here, goods are transported through social networks that bypass closed channels of conventional transportation, with their journeys documented and tracked. In this way each stage of its journey becomes part of the good, and the project becomes about the sociality of this transportation and its relationship to the product.

Sekula's film, on the other hand, tracks the globalized distribution of capital, people and related information and ideas, showing the opposite side of the story. Unlike **Company** and **Feral Trade** where the goods and their movements are socially connected with their production and distribution points, **The Forgotten Space** highlights the socio-political splits between goods, production and distribution, underscoring anonymous journeys taken by mass-produced goods. The forgotten space of the film is both these flows of capital, but also the sea as the continuously traversed terrain. Sekula's politics of the in-between deconstructs these flows and explores the mechanisms through which they are controlled by global markets in their relentless drive for profit.

But while Rich's and Sekula's work critically explore global movements of goods, **Company** reveals and explores the economic movements of communities and goods in terms of a specific local setting and the relationships of ownership that arise through these. In starting within a particular community and what can be produced within the local, the project makes visible all the movements between histories, participants and places to the producers and distributors of the goods within the locations of production and distribution, giving them a stake in the goods at every stage of the process.

Journeys of the Immaterial

The physical movements within the project are knitted together by a simultaneous exploration of invisible movements. These invisible movements are the continuous transmission and retelling of the historical and cultural contexts that frame the activities in **Company**. While the annual journey to the hopping fields of Kent by people from Stepney, Hackney and Bethnal Green was driven by an economic need, their temporary relocation generated its own culture, and the rituals, protocols and events that were condensed into those few

Gale Street Farm, Dagenham, c.1920.

Becontree Estate, Dagenham, 2015.

weeks have travelled through time, as stories told and retold, to become part of the histories and cultural memories that exist today.

The 'Hopping Afternoons' effect movements of this hop picking culture, by enabling hop pickers' memories to re-enter the present in a new context. By revisiting this history in the context of informal meetings with groups of people who were hop pickers, and people who weren't, the experience of hop picking for both hop pickers and non hop pickers comes back into the present. Rather than recreating a linear history of hop picking and the east London communities, the afternoons create a space where experiences that may have been overlooked in wider historical accounts are moved to the fore and stories can be connected from multiple perspectives.

The afternoons practice a kind of historical materialism by constructing a new set of relations between the present and the past, setting in motion a new set of movements that connect memories of hopping with a practice of producing beverages today. This process of recollection and practice might be approached through Walter Benjamin's description of historical materialism where the process of developing history is not linear, rather it happens when 'thinking involves not only a flow of thoughts, but their arrest as well ... [where it stops] in a configuration pregnant with tensions it gives that configuration a shock'.6 The collections of stories, memories, songs and rhymes that are revisited through the Hopping Afternoons create new configurations of the history and new points of departure from which to understand it.

Social Movements
Centred on the organization of groups of people within a specific locale, Company engages with and brings into its field of reference the concept of social movements on a number of levels, both historical and contemporary. From a historical perspective it connects to a number of manifestations of social movements from the nineteenth and twentieth centuries, both working and middle class.

While not a movement of the working class as such, the Temperance Movement of the nineteenth century was very involved in the hop pickers lives through the Church of England Temperance Society (CETS). In the late 1800s they organized missions in the hop gardens, providing tea, coffee and medical assistance to the pickers and their children. As part of these missions local well-to-do women would take mobile carts through the hop gardens giving out tea and coffee, before static centres were established.7 The Temperance Movement was founded on health and more often moral imperatives about how working class people should behave and didn't aim to change the lives, but to simply ameliorate their conditions. One might therefore assume that the CETS was also involved in the hop harvest because of the urban migrant

hop pickers' reputation for drunkenness and rowdy behaviour (local pub landlords were often said to serve them beer from jam jars rather than give them beer glasses), and to ensure that pickers maintained some kind of sober comportment in the fields.

Given that the hop pickers were mostly women with their children, perhaps what is more interesting to note here is how the history of hop picking ran in parallel to the growing momentum of the various movements that fought for women's rights in the late nineteenth and early twentieth centuries. There is no evidence to suggest that the hop picking women self-organized around any specific issues in relation to their hop picking conditions. However, the period during which families travelled to Kent to go hop picking saw an increased mobilization of women in relation to the workforce. From middle class organizations like the Langham Group who were forerunners of the Women's Suffrage Movement to the striking match girls at the Bryant and May Factories (many of whom would have also gone hop picking) there was a growing number of women in the UK becoming involved in the organization around working conditions and demands for equal rights. Furthermore, the increased involvement of women in the workforce during and after World War II and rise in living standards that, including regular holidays, also resulted in the decline of the east Londoner's hopping holiday by the early 1950s. Today's pickers, vastly reduced in numbers because of the mechanization of the picking process, are mostly migrant workers from Eastern Europe, introducing a new form of movement into the project's milieu.

Contemporary social movements referenced within **Company** focus on the current interest in, and activities around new practices of commoning, urban agriculture and community mobilization to build resilient regeneration. In a general and London-specific context there is an increase in communal and collective projects around local urban land use and new urban commons (New Cross Commoners, the Gleaning Network, Lea Valley Organics or **What Will the Harvest Be**, for example). There are also projects like **R-Urban** – discussed elsewhere in this book – initiated by atelier d'architecture autogérée in the town of Colombes outside Paris, which explores the possibilities for grass-roots regeneration through locally situated citizen projects. These projects aim to empower communities through the development of alternative and localized activities related to economies, and to encourage forms of regeneration on the community's terms, through advocacy and activities, rather than it being imposed through outside agencies with other interests.

Captured Movements and the Space of Art

Company is not a static artwork. The drinks produced within the project become 'hubs', where all these invisible movements intersect. As hubs they are static points that contain a complex of codes drawn from the re-movements of social

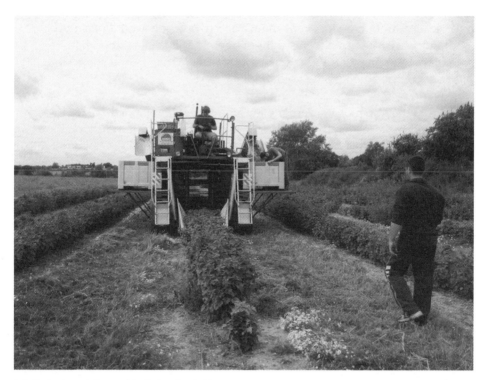

Left: Blackcurrant picking machine (before the gleaning begins), Feering Bury Farm, Essex, July 2015.

Right: Pulling the bines, hop garden, Kent.
Photo courtesy of John Smith.

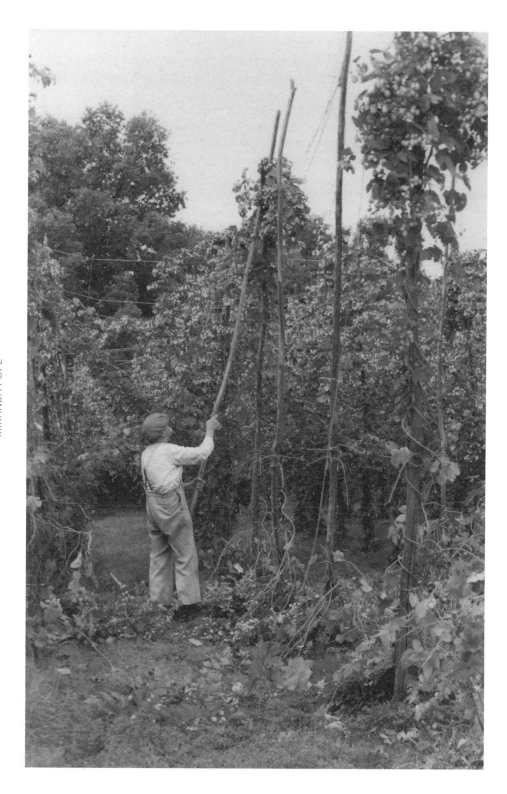

and political histories of the hopping community, and the economies of beer production in the nineteenth century and early twentieth century. The paths of these movements can be traced to these points, ready to move off into new directions through dialogue with people who engage with the drinks, where they become, as Rancière says, 'signs of history to be deciphered'.8 The drinks and their stories maintain the transmission of histories and memories through wider social dimensions, which occupy gaps and interstices between the narratives that we know and those that we haven't yet formed.

But **Company** is first and foremost an artwork, and by bringing these stories into public spaces in this context, its artistic boundaries have to be taken into account. The project can be understood therefore as a social model of history and beverage production, while simultaneously taking up the space of art. While it investigates movements of culture and goods, at the same time it moves the context within which they are talked about into new terrains. This space of art is the space in which all these movements are also able to happen.

These diverse collective activities occupy physical and invisible spaces of art through the motivation for its production, the contexts for its funding and the manifestation of its activities. They also move into and occupy a real social space of enterprise development that has no specific artistic agenda as such. The project therefore takes place in both spaces as well as occupying the space between both spaces, allowing the free movements of people, ideas and resources between them. The question of how its ontology as an artwork moves between being a state of art and a state of not art is played out in this movement between the two states. The two states within the artwork connect it to wider social fields, while at the same time creating a disconnect through a specific set of constraints – its artificiality as an aesthetic endeavour – as an artwork.

Relationships between artist, artwork and audience are also questioned here. Constituted through social activities that engage local communities, and motivated by an ambition to create a real, ongoing functioning social enterprise, the project's various spheres of activities do not set up a structured exhibitionary format. There is no audience as such. Rather, there are participants and collaborators who engage with the project across several social registers, and who by being involved in defining resources, production, marketing and distribution have both a social and economic stake in the project.

This co-existence of activities as art and non-art manifests itself as the transmission of ideas, cultures, knowledge and information between and across several heterogeneous fields of activity. In the words of Rancière, the artwork becomes a 'continuum of metamorphic forms [where] ... common objects may cross the border and enter the realm of artistic combination'.9 As activities,

resources and goods move inside and outside the space of the artwork; these movements are documented and thrown into relief, which produces another form of a politics of the in-between. This is a politics produced by all the artwork's participants in collaboration with the artist, and where the workshops, deals and distributions test out spatio-temporal boundaries for the artwork as well as the social activity itself. The activities allow people to move into and occupy public spaces from an active position, as participants who start from possibilities and potential, rather than seeing things as a predetermined set of circumstances that they fit into. This complicates their relationship with the space and allows new subjectivities to emerge. The aim here might be to rethink the space from within, to create an inclusive space with no overall governance; a space which could have, as Claude Lefort suggests: 'the virtue of belonging to no one, of being large enough to accommodate only those who recognize one another within it and who give it a meaning'.10

Such a space could only come into being and be maintained through ongoing, immaterial and physical movements that are in a state of continuous discourse. And this is nowhere more played out than in **Company**, where movements articulated through the project are also always themselves in movement within the project's framework. So it is a montage of movements, yes, but a montage of movements, always in movement.

NOTES

1
Henri Bergson, Matter and Memory, trans. Nancy Margaret Paul & W. Scott Palmer (London: Dover, 2004) p. 246.

2
David Harvey, Spaces of Global Capitalism: Towards a Theory of Uneven Geographical Development (London & New York: Verso, 2006) p. 123, emphasis in original.

3
Jacques Rancière, 'The Aesthetic Revolution and its Outcomes' in New Left Review 14 (March/April 2002) p. 133.

4
The project can be accessed at http://www.feraltrade.org/cgi-bin/courier/courier.pl [accessed 25-06-15].

5
More information about the film can be viewed at: http://www.theforgottenspace.net/static/home.html [accessed 25-06-15].

6
Walter Benjamin, 'Theses on the Philosophy of History' in Illuminations (London: Pimlico, 1999) p. 254.

7
This information was viewed at: http://yaldinghistory.webplus.net/page239.html [accessed 25-06-15].

8
Jacques Rancière, 'The Aesthetic Revolution and its Outcomes' in New Left Review 14 (March/April 2002) p. 145 [pp. 133–151].

9
Ibid. p. 143

10
Claude Lefort, 'Human Rights and the Welfare State' in Democracy and Political Theory (Minneapolis, MN: University of Minnesota Press, 1988) p. 41.

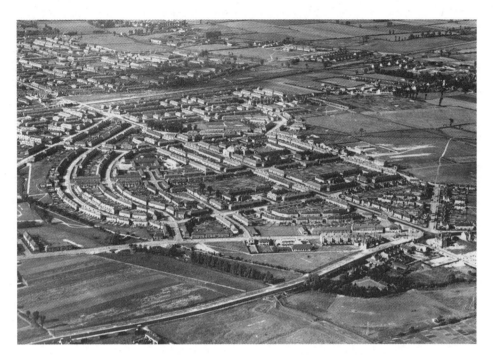

Becontree Estate construction.

Eastbrookend Country Park,
near Millennium Centre, 2015.

R-URBAN
RESILIENCE

This article is an edited and shortened
version first published in ATLAS: Geography,
Architecture and Change in an Inter-
dependent World by Renata Tyszczuk,
Joe Smith, Melissa Butcher and Nigel Clark,
Black Dog Publishing, London, 2012.

Constantin Petcou, Doina Petrescu

Abstract

R-Urban is a bottom-up framework for resilient urban regeneration initiated by atelier d'architecture autogérée (aaa). The strategy explores current possibilities for co-producing urban resilience by introducing a network of resident-run facilities that form local ecological cycles and eco-civic practices. This article tries to demonstrate that progressive practices, addressing the need to reactivate and sustain cultures of collaboration and proposing new tools adapted to our times of crisis and austerity, are possible while acting locally and at a small scale. R-Urban has been conceived as a participative strategy based on local circuits that activate material (e.g. water, energy and food) and immaterial (e.g. local skill, socioeconomic, cultural and self-building) flows between key fields of activity (e.g. the economy, habitation and urban agriculture) that exist or are implemented within the existing fabric of the city. R-Urban started in 2011 in Colombes, a suburban town of 84,000 inhabitants near Paris, in partnership with the local municipality and a number of organizations, and involving a range of local residents.

'R'

'R'-Urban relates directly to the three 'R' imperatives discussed in any ecological approach: i.e. Reduce, Reuse and Recycle, and suggests other iterations, such as Repair, Redesign and Rethink. In addition, the term indicates explicitly that R-Urban reconnects the urban and the rural through new, more complementary and less hierarchical kinds of relationships. The 'R' of R-Urban also reminds us that the main goal of the strategy is 'Resilience'.

'Resilience' is a key term in the context of the current economic crisis and resource scarcity. In contrast to sustainability, which focuses on maintaining the status quo of a system by controlling the balance between its inputs and outputs, without necessarily addressing the factors of change and disequilibrium, resilience addresses how systems can adapt and thrive in changing circumstances. Resilience is a dynamic concept that does not have a stable definition or identity outside the circumstances that produce it. In contrast to sustainability, which tends to focus on maintaining the environmental balance, resilience is adaptive and transformative, inducing change that offers huge potential to rethink assumptions and build new systems (Maguire & Cartwright, 2008). Although the current resilience discourse should not be embraced uncritically, without acknowledging the sometimes naïve and idealistic comparison of social to biological systems and their capacity to adapt to engender well-being, the concept of 'resilience' has the potential to include questions and contradictions addressed in political ecology terms.1 R-Urban is thus not about 'sustainable development' but about societal change and political and cultural reinvention, addressing issues of social inequality, power and cultural difference. The resilience of a social system also implies the capacity to preserve specific democratic principles

and cultural values, local histories and traditions, while adapting to more ecological and economically mindful lifestyles. A city can only become resilient with the active involvement of its inhabitants. Resilience is for **R-Urban** a catalyst of urban activation, innovation and creativity.

Models of Resilient Cities: The Garden City, Regional City and Transition Town

Although anchored in everyday life and committed to radical change, **R-Urban** is simultaneously part of a specific tradition of resilient development, starting with Howard's Garden City and Geddes's Regional City, and continuing today with the Transition Town.

In 1889, Ebenezer Howard published his book **Garden Cities of To-morrow**, proposing a model utopian city that would combine qualities of urban and rural life. The book was thought to provide a solution to the urban crisis that followed the agricultural depression of the late nineteenth century, and generated a whole movement. The model proposed by Howard supposed a mechanism through which ownership would be transferred gradually from financial capitalists to inhabitants, with the idea that rent payments would maintain a local welfare state. The cooperative aspects of the original Garden City model were expressed not only in community gardens and communal kitchens, but also in mechanisms for space appropriation by inhabitants. These mechanisms have not been implemented in most of the urban and suburban developments that claimed to follow these ideas, which adopted only the urban form and not its social and political principles.

Similarly, a few decades later, Patrick Geddes proposed a more naturalistic understanding of the city, establishing the principles of a 'region city' in his books **City Development** (1904) and **City in Evolution** (1915). With his background in biology, Geddes stated that, before starting any kind of urban planning, one should thoroughly study the natural resources at regional scale and analyse the existing economic and social dynamics. The Regional City is defined by complex relationships between climate, vegetation, animals and economic activities, which all influence human and societal evolution. Geddes's vision of the city emphasizes institutions and civic life, as well as social interaction and public space. An egalitarian relationship between men and women is carefully considered together with various modes of local-scale self-management. Across a geographic vision, the region is considered in its capacity to promote social and political regeneration. Geddes had the occasion to partially apply his theoretical analysis, but his vision of the Regional City has been simplified and reduced, just as the Garden City was, in its modernist applications.

More recently, Rob Hopkins published the **Transition Handbook** (2008), which soon became the reference of a whole 'Transition' movement. The concept

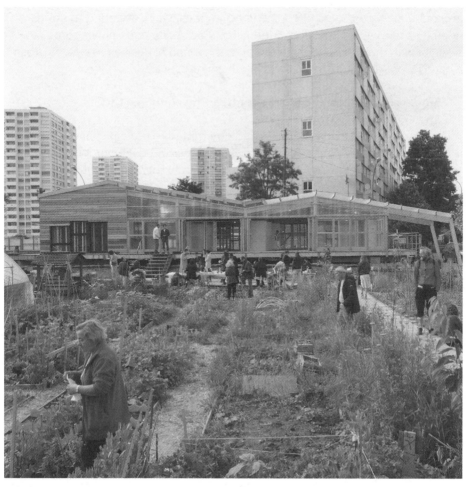

Agrocité, Colombes, Paris.
Courtesy of aaa.

of a 'Transition Town' does not designate a specific utopian model to be built, but instead proposes a guide to be followed by grassroots organizations that want to initiate transition dynamics in their existing towns. It is no longer a matter of a movement proposing a new type of city, but a set of rules and principles for the bottom-up adaptation of existing cities. Rather than from planning, this model of development emerges from permaculture. The driving dynamic is that of 'transition' within the horizon of a challenging future whose main parameters are peak oil and climate change.

In contrast to these models, **R-Urban** is not the direct application of theory but tries to develop both an exploratory practice and a theoretical analysis that constantly inform each other. **R-Urban** shares with the Garden City concept an interest in combining qualities of urban and rural life in the context of existing cities and creating a closed loop in terms of cycles of production and consumption. It also shares an interest in cooperative organization and mechanisms by which inhabitants can appropriate and manage space and in how these mechanisms translate into design solutions.

R-Urban picks up from the Regional City concept the idea of regional dynamics, but based in this case on the bottom-up initiatives of local inhabitants. It considers both large-scale processes and small-scale phenomena. Global concerns are addressed locally, but within existing conditions. **R-Urban** also incorporates many Transition Town principles. However, in **R-Urban** resilience is not understood as an imperative to maintain the existing order but as a necessity to transform and invent new possibilities, as a driver of collective creativity. Through its pilot projects and collective facilities, **R-Urban** tries to make visible the solidarity networks and ecological cycles that it creates.

Micro-Social and Micro-Cultural Resilience

Unlike other initiatives that deal exclusively with sustainability from a techno-logical and environmental perspective, **R-Urban** advocates a general 'change of culture', understood as a change in how we do things, in order to change our future. The future is culturally shaped as much as the past is, because culture gives us 'the capacity to aspire' (Appadurai, 2004).

R-Urban proposes new collective practices that, in addition to ecological footprint reduction, contribute to reinventing proximity relationships based on solidarities (i.e. ways of being involved and deciding collectively, sharing spaces and grouping facilities, and rules and principles of cohabitation). In neoliberal societies, urban lifestyles have progressively abandoned various forms of solidarity that were perceived as inadequate or outdated. Notably, however, these relationships of reciprocity constitute the very basis of social progress. In his analysis of the connections between the economy and politics (inspired by Tarde's sociology), philosopher Maurizio Lazzarato (2002) critically

describes the civilization of 'progress' as 'a constantly renewed effort to replace reciprocal possession with unilateral possession' (authors' translation; p. 354). It is precisely these relationships of reciprocity and solidarity that are missing from today's urban environment. The dwelling models proposed by R-Urban aim at restoring these solidarity relationships through processes that implicitly produce sociability, shared spaces, common values and affective relationships.

Transformation must occur at the micro scale with each individual, each subjectivity, and this is how a culture of resilience is constructed. As Rob Hopkins puts it, 'resilience is not just an outer process: it is also an inner one, of becoming more flexible, robust and skilled' (Hopkins, 2009, p. 15). The culture of resilience includes processes of reskilling, skill sharing, social network building and mutual learning. These micro-social and micro-cultural practices, which are usually related to individual lifestyles and practices (e.g. growing food and collecting waste, sharing a car and exchanging tools and skills with neighbours), prompt attention to details, singularities, and the capacities for creativity and innovation that operate at the level of everyday life. R-Urban maps in detail this local capacity to invent and transform but also, in parallel, the administrative constraints that block it, proposing ways of bypassing these constraints through renewed policies and structures.

A political ecology approach, like that of R-Urban, does not just positively and uncritically propose 'improved' development dynamics, but also questions the processes that bring about social justice and inequitable urban environments.2 People such as David Harvey (2008) argue that the transformation of urban spaces is a collective rather than an individual right, because collective power is necessary to reshape urban processes. Harvey describes 'the right to the city' as the citizen's freedom to access urban resources: 'it is a right to change ourselves by changing the city' (p. 23). In this sense, R-Urban follows Harvey's ideas and facilitates the exercise of this 'right' through processes of appropriation, transformation, networking and use of city infrastructure. R-Urban perhaps differs from Harvey in scope, as it does not seek to instigate a large-scale global movement to oppose the financial capital that controls urban development, but instead seeks to empower city inhabitants to propose alternative projects where they live and to foster local and trans-local networks, testing methods of self-management, self-building and self-production. Here R-Urban is perhaps closer to Henri Lefebvre's idea of 'the right to the city'. Lefebvre imagines a locally framed emancipatory project, emphasizing the need to freely propose alternative possibilities for urban practice at the level of everyday life. He proposes a new methodology, called 'transduction', to encourage the creation of 'experimental utopias'. Framed by existing reality, this would 'introduce rigour in invention and knowledge in utopia', as a way of avoiding irresponsible idealism (Lefebvre, 1996,

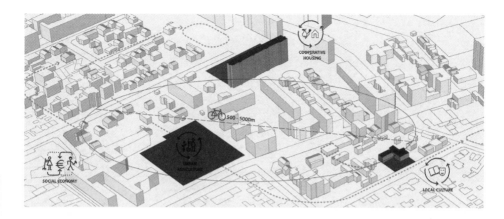

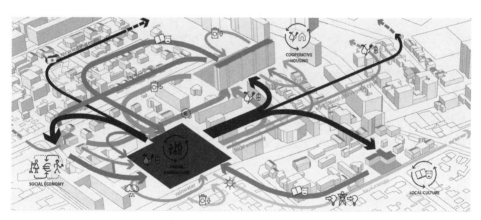

R-Urban diagrams. Courtesy of aaa.

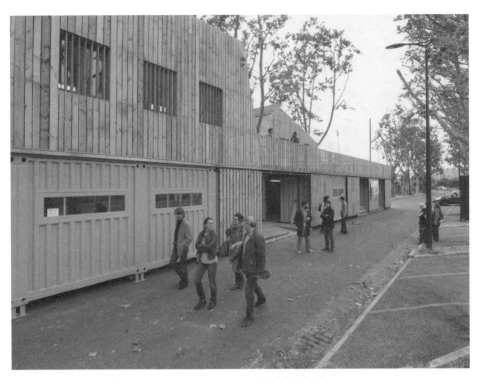

Recyclab, Colombes, Paris.
Courtesy of aaa.

pp. 129–130). Lefebvre underlines the key role of urban imaginaries in understanding, challenging, and transforming the urban and opening the door to a multiplicity of representations and interventions.

From this perspective, **R-Urban** is a 'transductive' project, both rigorous and utopian, popular and experimental. It is a bottom-up approach based on the aggregation of many individual and collective interventions that complement each other, forming metabolic networks that stimulate circulatory changes and simultaneously determine each other. Such networks will accommodate multiplicity and valorize imagination at all levels.

Democratic Ways of Working, Producing and Dwelling

The modes of production introduced by Ford have desubjectivized labour relations through the progressive accumulation of repetitive tasks that, by their fragmented and repetitive nature, have destroyed the long-term vision of labour goals and results.3 Under post-Fordist labour conditions, micro-social universes are created only in connection with the leisure domains (e.g. cinema, holidays, sports, parties and, more recently, events organized via social networks). This 'free-time' sociality as the only form of sociality is alienating: it is intended to fill an existential void, while being implemented insidiously and radically modifying collective values and behaviours.

R-Urban tries to restore the possibility of reappropriating and resubjectifying labour as a fundamental ontological activity, while developing links and transversalities between work and emancipatory social, cultural, political and environmental values. The diversity of activities developed by **R-Urban** should allow not only a new assemblage of and emerging agencies, but also a gradual disassembly of a system in crisis. To slowly escape from the generalized footprint of the neoliberal economy, which excludes other forms of material and symbolic exchange, we must dismantle one by one our ties to the market system and withdraw from the system to enable the change. We must undo, disassemble – des-agencer, as Deleuze and Guattari might say – and step outside the neoliberal logic in order to reassemble new ethical, environmental and long-term ecological agencies.4 This reassembly is a collective act based on the convictions of each participant. The **R-Urban** strategy relies on off-market elements that can potentially leave the system (e.g. interstitial spaces, community associations and marginalized or emerging practices) and can be integrated into new agencies and collective processes of re-assembly.

The resilience **R-Urban** promotes using minimal means allows for considerable social, cultural and subjective diversity. This is similar to the situation in ecology in which, as Clément (2004) noted, 'the poverty of a soil [i.e. in a pedological sense] is a gauge of diversity' (p. 188). The minimal economy of means also implies a space that is not over designed and provides for a diversity

of agencies and reconfigurations: it guarantees a capacity to welcome new-comers into the project.

'Democracy', as Rancière (1998) says, 'is neither in the realm of communal law assigned by juridical-political texts, nor in the realm of passions. It is first and foremost the place of all these places where factuality is affected by contingency and egalitarian resolution. In this way, the street, the factory, or the university can be places for such resurgence' (authors' translation; p.126). The collective spaces initiated by **R-Urban** will constitute, as in aaa's other projects, places of permanent negotiation, learning by doing, and the bottom-up reconstruction of the political fundamentals of democracy, such as equality of representation, general interest in the common good, liberty and responsibility and collective governance. These spaces are open to reconfiguration, introducing the dynamics of self-management and of responsibility, initiative and negotiation. This is the basis of any democratic functioning.

Diverse *Ecolomies*
R-Urban promotes an 'ecological economy', i.e. an economy driven by ecology or, more precisely, by principles of political ecology – what we call an 'ecolomy'.**5** It is the direction to be taken if we want the economy to be adapted to different territorial scales and developed on a long-term basis under principles of solidarity and sharing.

Economic diversity, as in all ecosystems, creates resilience. In general, the greater the variety in any sector of enterprise forms, ways of performing and remunerating labour, accessing property, transacting (sharing, giving and exchanging) and financing (saving and borrowing), the less vulnerable an economy is to crisis and stress. It is important to recognize difference and to frame it. In this way, as Bruno Latour noted, it is much easier to act to 'make a difference' (Latour, 2005, p.253). This is exactly what a strategy like **R-Urban** offers: it provides a framework for a diversity of economic forms to emerge and sustain themselves though diverse networks: cooperatives, associations, social enterprises, self-employed jobs, free exchanges and other voluntary initiatives are all encouraged to contribute to the locally closed ecological circuits.

By introducing this capacity for multiple forms of co-production (e.g. green productive spaces, active dwellings and local production and service hubs), **R-Urban** enables new forms of ecolomy within the existing urban conditions and the production of a range of new commons.**6**

Commons and Commoning
The question of the commons lies at the heart of discussions of democracy today. In some recent texts, Michael Hardt and Antonio Negri (2004) define the commons as something that is not discovered but is produced biopolitically:

'We call the current dominant model "biopolitical production" to underline the fact that it involves not only material production in straight economic terms, but also that it affects and contributes to producing all other aspects of social life, i.e. economic, cultural and political. This biopolitical production and the increased commons that it creates support the possibility of democracy today' (authors' translation; pp. 9–10). A sustainable democracy should be based on a long-term politics of the commons as well as on social solidarities understood as commons. 'Creating value today is about networking subjectivities and capturing, diverting and appropriating what they do with the commons that they began' (authors' translation; Ravel and Negri, 2008, p. 7).

According to Ravel and Negri (2008), the contemporary revolutionary project is about this capturing, diverting, appropriating and reclaiming of the commons as a constituent process. It is at the same time a re-appropriation and a reinvention. This undertaking needs new categories and institutions, forms of management and governance, space and actors – an entire infrastructure that is both material and virtual.

R-Urban tries to create this new infrastructure, which is at the same time a re-appropriation and a reinvention of new forms of commons, ranging from collective self-managed facilities and collective knowledge and skills, to new forms of groups and networks. The facilities and uses proposed by R-Urban will be shared and disseminated at various scales, progressively constituting a network open to various users, including adaptable elements and processes based on open-source knowledge. The resilient city is a city of sharing, empathy and cooperation: it is a city of commons.

We have learned from our previous projects (i.e. ECObox and Passage 56)7 that, to avoid opposition and delay, one can tactically use easily accessible space. Rather than buying land, the R-Urban land trust bypasses the fixation on the idea of property and negotiates land for use (both short and long term) rather than for possession. The right to use as opposed to the right to possess is an intrinsic quality of the commons. As in previous projects, we focus especially on urban interstices and spaces that escape, if only tempo- rarily, from financial speculation. This interstitial strategy involves spaces, actors, local partners and time. This is also the position of Holloway (2006) who, after having analysed various forms and initiatives to transform society, concludes that 'the only possible way to think about radical change in society is within its interstices' and that 'the best way of operating within interstices is to organize them' (authors' translation; pp. 19–20).

Pioneering *R-Urban* Co-Production
R-Urban is on the way. Over the next few years we will nurture the diverse economies and initiate progressive practices within the R-Urban network

in Colombes. We have designed **R-Urban** to be a process and infrastructure that can grow with time, being easy to appropriate and reproduce. We will be testing it for a while, before leaving it to proliferate by itself. Will it succeed? If so, for how long? These are questions to be answered in a few years. For the present, it is a visionary attempt to realize more democratic co-produced resilient regeneration in a suburban context; it is a process specifically designed to be appropriated and followed-up by others in similar contexts.8

NOTES

1
We are joining here with those political ecologists who criticize the superficial understanding of politics, power and social construction promoted in resilience rhetoric (see, e.g. Hornborg, 2009, pp. 237–265).

2
Some of these ideas were developed in Clare Brass, Flora Bowden, Kate McGeevor's paper 'Co-designing Urban Opportunities', on line http://www.scibe.eu/publications/ [accessed 05-05-2011].

3
These ideas have been developed elsewhere: notably in the work of Ivan Illich and Andre Gorz.

4
On disassembling – 'des-agencer', see Gilles Deleuze, Felix Guattari, **Capitalisme et schizophrénie 2**, Mille Plateaux, Les Éditions de Minuit (1980, p. 17ff).

5
The terms 'ecolomy' was coined by Bjarke Ingels in his article 'The Joys of Ecolomy: How to Make Sustainability a Haven of Hedonism' in Ilka and Andreas Ruby, Re-Inventing Construction (Berlin: Ruby Press, 2010) pp. 55–66. Ingels draws inspiration from the idea of an economy of ecology, based on production and consumption rather than reduction and abstention. He promotes a sort of 'cradle-to-cradle' approach that channels new flows and establishes closed cycles. However, our understanding of 'ecolomy' extends his idea of 'economy of ecology' to its inverse: an 'ecology of economy', i.e. an economy aware of the relationships it creates and driven by ethical principles.

6
The 'commons' traditionally defined the natural resources of an environmental space, such as forests, the atmosphere, rivers and pasture – the management and use of which was shared by the community. It constituted spaces that no one could own but everyone could use. The term has now been enlarged to include all material or virtual resources collectively shared by a population.

7
The **ECObox** (Paris 18e) and **Passage 56**, St. Blaise Street (Paris 20e) projects of aaa consist of the interim occupation by residents of interstitial spaces and temporarily available plots resulting from demolitions and awaiting development. These plots are transformed into self-managed spaces that host collective activities such as gardening, cooking, cultural events and political debates. This occupation, which is meant to be temporary, can be temporally extended due to the mobility of the infrastructure and the territorial expansion of the strategy, allowing the projects to be moved and reinstalled opportunistically in new locations (for more detail, see http://www.urbantactics.org/).

8
In June 2014 the newly elected local municipality in Colombes has withdrawn its support for the R-Urban project and is instead threatening its existence by demanding the demolition or relocation of Agrocité in order to replace it with a temporary car park. In a parallel move by the municipality, Recyclab is also being forced to leave by 30 September 2015, without any concrete reason given. aaa together with a large local and international community of supporters is contesting this decision and have since signed a petition to safe R-Urban (for information, check out https://www.change.org/p/yes-to-preserve-r-urban-in-colombes-no-to-the-temporary-car-park-that-is-planed-to-replace-it-saverurban). #saveRURBAN.

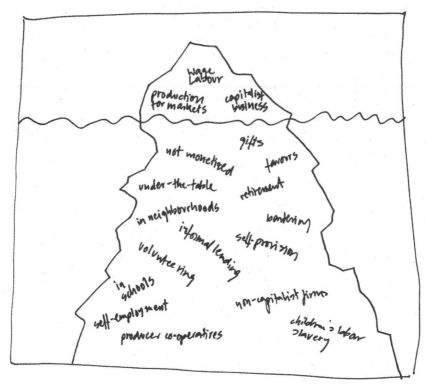

Economy as an Iceberg

[Labels within the iceberg:]
Wage Labour
production for markets
capitalist business
gifts
not monetized
favours
under-the-table
retirement
in neighbourhoods
bartering
informal lending
self-provision
volunteering
in schools
non-capitalist firms
self-employment
children's labor
slavery
producer co-operatives

Economy as a Drinks Cabinet – referring to J.K.Gibson-Grahams's use of the iceberg/economy comparison.

'The image of the economy as an iceberg is one way of reframing which practices are included and valued as "economic". When we see the whole iceberg we start to recognize the vast range of practices, places, organizations and relationships that contribute to daily survival. What was once seen as "alternative" is but part of the already existing diverse economy.'

From J.K.Gibson-Grahams' essay 'Economic Meltdown, or What an Iceberg Can Tell Us About the Economy', for *Trade Show*, Eastside Projects Birmingham, December 2013.

Sketches by Kathrin Böhm.

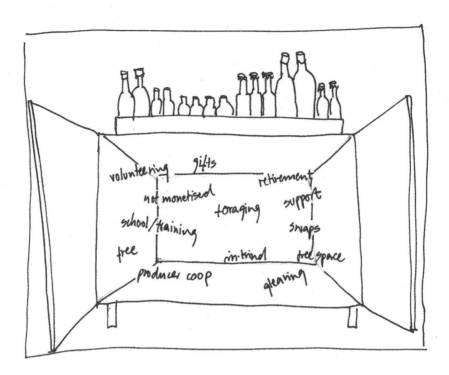

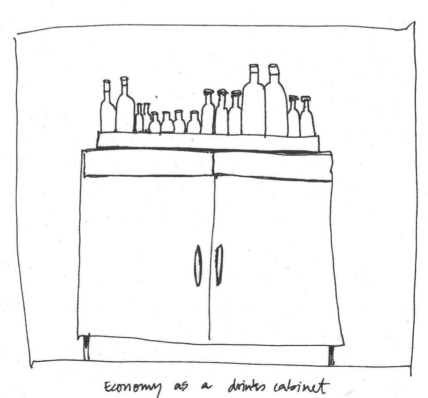

Economy as a drinks cabinet

BACK-TO-THE-LAND

David Boyle

There I was in Bristol some years ago, running a surprisingly packed session on the future of money, alongside the Schumacher Lectures, and feeling rather pleased with myself. I had never managed to attract a turn out like that before. As I left, I was taken aside by a young woman – in her early twenties, I imagined – and asked for my advice. I preened myself. What would she ask? How to launch a local currency? How to revitalize her neighbourhood?

'I wanted your advice about how to launch a new goat farm', she said. My spirits sank. Not only had I no idea, but I didn't even know anyone who had any idea.

It occurred to me afterwards that we were living through a new period of radicalism, where a younger generation interested in change were interpreting their radicalism in terms of growing things or farming or raising goats. And I could understand it too.

People are angry the way globalism has developed, how multi-nationals and supermarkets control and restrain us as consumers whilst exploiting natural and human resources in dangerous measures. Growing your own vegetables becomes a political act, a defiance of the monopolies that dominate our lives. So is putting your name down for an allotment.

This new emerging radicalism exists on both sides of the Atlantic and includes intentional communities, smallholdings, community-supported agriculture as well as the huge effort and imagination now going into hundreds of Transition Towns to set aside spare land to grow food. Community gardens, shared growing schemes, agricultural co-operatives, guerrilla gardening and urban foraging are becoming part of many urban and rural neighbourhoods and are a visible and accessible part of new approaches to using land and growing food.

We have gone two generations when pigs and hens disappeared from suburban back gardens, only to creep back again via 'The Good Life' in the 1970s, and now garden hens are increasingly common again.

Behind all this there is a distant folk memory that maybe, somewhere, something similar happened before. There is a strange nostalgia that seems to be peculiarly, but not exclusively, English – both for the time after the agricultural depression of the 1870s, which depopulated the rural areas, and for the days when urban dwellers headed off to the countryside in the summer to pick the fruit. Or perhaps this is a whiff of the 1970s, and the kind of commune-style living that swept transatlantic youth after the end of the hippy era; perhaps it actually stretches much further back.

There is an even deeper memory, of a lost radical tradition in English life that proposed going back to the land to provide people with the basic means of subsistence. 'Suppose people lived in little communities among gardens and green fields, so that they could be in the country in five minutes' walk', wrote William Morris in 1874, when he was first developing these ideas, 'and had few wants; almost no furniture for instance, and no servants, and studied (the difficult) arts of enjoying life, and finding out what they really wanted: then I think one might hope civilization had really begun.'1

Sixteen years later, Morris published the full vision in his utopian novel **News from Nowhere**, describing his journey in a medieval future, where London has been ploughed over and the Houses of Parliament converted into a dung store. It seemed unique, but it was in so many ways an articulation of a tradition of radicalism that was at the same time a critique of conventional wealth, a vision of how people could supply their own needs and an interpretation of the spiritual power of work. Morris was socialist, in a sense, but nothing like the urban industrial socialism of Marx or Engels.

It was a tradition that seems now to be populated by a series of intellectual cranks – William Cobbett, Samuel Palmer, John Ruskin, William Morris, Hilaire Belloc, G. K. Chesterton, Eric Gill and on into the present day, via Henry Williamson and E. F. Schumacher. Their politics was apparently diffuse as well, covering Radicalism (Cobbett), High Toryism (Palmer and Ruskin, or so he said), Socialism (Morris, eventually), Liberalism (Belloc and Chesterton at first), even – by the 1930s – Fascism (Henry Williamson).

Yet strip away the political labels, and their political approaches look remarkably similar, including:

— Belief in a golden age of agrarian independence and equality, based on the rights to land holding, swept away in a great Original Sin – whether it was the Norman Conquest, the Enclosures, the Dissolution of the Monasteries or the Industrial Revolution.
— A longed-for return to those peasant values of thrift and independence, based on a programme borrowing from the best of medieval economics – whether it is common land, the guild system or the concept of the Just Price.
— Bitter scepticism about the conventional values of wealth, power and money, and the delusions of money as a measure of value compared to the values of nature.
— Scepticism about mainstream or academic education.
— Diagnoses of the division between rich and poor based on urban greed, the manipulation of money, and the theft from the poor of the means of livelihood on the land.

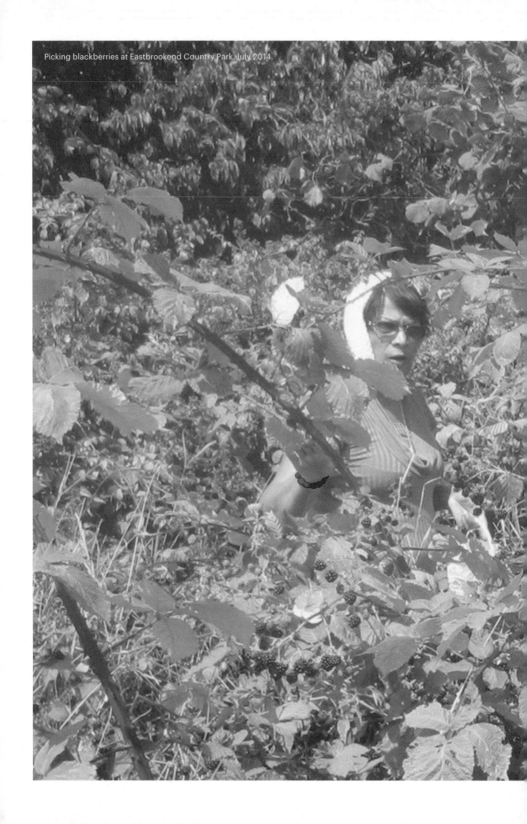
Picking blackberries at Eastbrookend Country Park, July 2014.

— The alternative interpretation of wealth: that creative human life, lived with work and life in harmony, close to the seasons, is potentially spiritual and sacred.

Of course what primarily seems to hold these people together is their conviction, to a greater or lesser extent, that national salvation lay in persuading the urban poor to go 'back-to-the-land' and, through small-scale ownership or control of land, find a basic economic independence.

It was a critique that reaches back into classical literature, to Hesiod and Virgil, who used the land, and the plight of the land, as a metaphor for the moral health of the nation. But in England, once the Industrial Revolution was firmly under way, politics shifted to more urban concerns, and we might assume that was the end of it. The romantic tradition in the arts continued to express the same kind of emotions that Virgil did, yet stubbornly, and despite every opportunity taken to declare it dead – beyond dead in fact – the old back-to-the-land tradition has remained alive in England.

Those who espouse it have been dismissed as unconnected cranks, throwbacks to a medieval arcadia that never existed. They have been treated as romantic artists whose trespass into the political arena was an unfortunate blot on the lives of otherwise exemplary men of letters. But seen in their true light, they actually represented different expressions of the same tradition. More than that, they were the tip of the iceberg while, below the surface, the great tradition of agrarian radicalism – the back-to-the-land tradition – is alive and well and may be on the point, finally, of reviving itself as a potent political force.

It seems, on the face of it, extraordinary that a political creed that has something as antique as the glorification of the peasant life at the heart of it should survive the Industrial Revolution and into the nineteenth century. Yet in 1927, nineteen centuries since Virgil, there was G. K. Chesterton in his **Outline of Sanity** urging a new kind of society based on a renewed peasantry.2

England amongst many other places is alive with the kind of language that would have warmed Chesterton's heart: allotments are increasingly popular, people come out on the streets and campaign against the crushing impoverishment and a dominance of greed and waste in food production. These campaigns, on the face of it, seem to be represented by no mainstream political tradition. The arguments are being forged afresh, as if no campaigner had ever made such an argument before. When all along, is the evidence of a suppressed political tradition that could be revived – consulted at least – in defence of real food, real countryside and real life. This book may even be part of it.

The trouble is that back-to-the-land is barely discussed in polite political circles, even in England, where we sing William Blake's **Jerusalem**, but barely consider the ideas behind it. Where nostalgia for laws before our Norman rulers arrived in 1066 remained a dangerous idea even into our own day – why else did school history begin with such determination every year with the Norman Conquest in 1066? Why else were the kings who reigned before that date dismissed as semi-legendary Dark Age figures, their names and numbers excised from list of monarchs that began so arbitrarily with William the Conqueror? Why otherwise than that the establishment – although they had forgotten why – feared the appeal to Old Laws and old pre-feudal ways, and the powerful radical and romantic tradition that underpinned them?

When we come to look more closely at those who have inspired the tradition, it seems to be based geographically more precisely than England: it is south east England. Cobbett was from Farnham in Surrey. Jefferies died outside Worthing. Belloc worshipped Sussex. Palmer painted around Shoreham in Kent. Morris, Ruskin and Williamson were from the fringes and outskirts of London. Blake and Chesterton were from London itself, though Blake lived for some time on the Sussex coast.

The English tradition that battles with the results of industrialization seems to have emerged in that English region where the destruction of agrarian life has gone further than in any other. It is partly a thoughtful response to that loss, but otherwise it defies categorization. It manages to be both nostalgic and revolutionary at the same time.

That nostalgia lies behind so many of the heroes of the tradition before it had emerged fully after industrialization. Like the yeoman farmer Thomas Foster, whose impassioned shout from the choir in Louth in Lincolnshire in October 1536, that they should follow the cross, launched the Pilgrimage of Grace against the selling off of monasteries.

Or the Parliamentarian, Colonel Edward Whalley more than a century later who wanted to roll back on enclosures in the face of a new parliamentary enthusiasm for them, before he fled under the threat of arrest after the Restoration all the way to New England (where he was supposed to have lived in a cave).

Or Dr Peter Chamberlain, surgeon and Anabaptist after the English Civil War, whose proposal for a national bank to lend money to the poor to cultivate waste land and forests never happened – perhaps because of his accompanying proposal to use the nation's palaces as agricultural communes.

Longbridge Road junction with Goodmayes Lane,
Dagenham, 1925.

Or Gerald Winstanley, the Digger leader, struggling to make the earth a 'Common Treasury' at St. George's Hill, Weybridge.

Or another century after that, the agricultural reformer Arthur Young, who changed his mind about enclosures after forty-six volumes of his **Annals of Agriculture**, claiming that: 'I had rather that all the commons of England were sunk in the sea, than that the poor should in future be treated on enclosing as they have been hitherto.'

But what stands out, perhaps most of all, is the parallels between their approach to spirituality, work and religion. Most of the back-to-the-land pioneers seem to have been attracted by an idea that work on the land could be spiritually uplifting (which is where Ruskin influenced Gandhi), and that this may have held together their common attraction – either for the medieval revival or for Catholicism or Anglo-Catholicism, or sometimes for all of them.

The problem for most of them is that their solutions tended to be vague in the extreme. It was never clear how the Distributists would provide land for every-one, or how Chamberlain's bank would work. The disconnect with parliamentary politics meant a fatal divide with political practicality. Perhaps only the Liberal MP Jesse Collings, who struggled in Parliament for nearly four decades to provide effective legislation on allotments and smallholdings, really managed to combine the two. Otherwise the righteous anger of Cobbett, Ruskin and Morris was not enough, without being allied to the kind of practical followers and successors of Gandhi, who made a practical success of land reform in India.

You will notice something peculiar about this particular list of back-to-the-land pioneers. They are all men, and this is significant. It was originally a deeply conservative bundle of ideas about the importance of the household economy, advocated by people who – Cobbett excluded – didn't do much growing themselves. But during the twentieth century, something began to change: women began to lead parallel movements, which derived mainly from Morris's work. Gertrude Jekyll led a garden design movement based on simplicity and scale. Eve Balfour took the organic farming techniques she saw in India and popularized them back home.

Then, in the 1980s, radical women were in the lead. The Chipko protesters in Uttar Pradesh, who first protected their forests from loggers by hugging them, were women. The Green Belt movement in rural Kenya, led by Wangari Maathai, was a women's movement. So was the huge Japanese consumer co-op, the Seikatsu Club in Tokyo, with the slogan 'politics from the kitchen'. The key voices in the movement now – from Rosie Boycott in London to Pam Warhurst in Todmorden or Severine von Tscharner Fleming of the US Greenhorn movement – are women. Those most likely to apply for allotments

now are no longer retired men, but single parents, and often single mothers. Wander around the allotment space opposite my front door in Crystal Palace in south London and you will see as many women as men working in their makeshift and productive environment, an amazing advertisement for informal solutions.

But the movement is also diverse in other ways too. There are Chinese plots, Jamaican plots, Portuguese plots, Irish plots, plots with plants from Palestine and the Caribbean, each one recognizable as distinctive, but knitted together by the same cooperative spirit.

As women have taken a lead, the movement has become more practical. The Transition movement from the UK is a rare sign of practical action linked to back-to-the-land. They are an object lesson in how to make things happen locally.

It seems extraordinary that back-to-the-land is back. The allotments movement left the doldrums sometime in the mid-1970s and there is now unprecedented demand for allotments, with waiting lists as long as forty years in one London borough.3

There is a growing awareness of the loss of other commons than common land, just as the tradition from Cobbett onwards emerged as part of an awareness of the enclosures – whether these are planetary support structures to other forms of shared space and infrastructure.4 There is also an emerging narrative that – just as Cobbett saw it – it is the loss of these other commons which is impoverishing people. At the same time, the so-called 'sharing economy' is beginning to rebuild commons in a small way by using spare capacity more effectively, and that applies particularly to food.

These issues may seem archaic to some people, but they are also instantly recognizable. This loss of land is a cultural narrative that also delves into one interpretation of our history, which was acted out so successfully and emotionally during the Olympics opening ceremony in 2012 – the loss of agrarian innocence – and it explains a little why that so caught the imagination of so many of those who watched.

These are not trends in conventional parliamentary politics, but they are very much emerging on the campaigning fringe, in phenomena like Occupy and the urban agriculture movement. The same challenges are there – the perennial problem about access to land, especially with urban land at such an extraordinary premium in many cities. The land reform movements in Scotland and

Left: View from Eastbury Manor House, Barking.

Right: Picking elderflower in Eastbrookend Country Park, with Molly the horse, May 2015.

Latin America have had some success, and against extraordinary odds, but this agenda is still enormously problematic – and land in England, which in some ways gave birth to back-to-the-land, remains as expensive and exclusive as it ever was.

There are criticisms you can make of back-to-the-land. It appears to opt out of conventional politics by being overwhelmingly practical. There are strengths to that but there are also weaknesses and vulnerabilities. It is not so much apolitical in the conventional way, but more anti-political. It is sceptical about conventional politics, just as it is sceptical about conventional education. It rejects conventional 'solidarity' in favour of a bit more digging.

Yet back-to-the-land is also a tradition that recognizes the deep need people have, locked deep into the cities, for contact with nature, for green space and changing seasons. It also engages closely with two very contemporary preoccupations.

First, it recognizes people's needs for fulfilling, independent work. Second, it tackles the urgent need people have for some measure of economic independence. Both these would have been recognized by those East Enders who travelled down to Kent every summer to help with the harvest, drink and have fun. That tradition is all but forgotten, but the reasons for it still apply, and all the more so today.

NOTES

1
Quoted in Fiona MacCarthy,
William Morris: A Life for Our Time
(London: Faber, 1994) p. 315.

2
G.K. Chesterton, An Outline of Sanity
(London: Methuen & Co. Ltd, 1926).

3
Nick Hope, Victoria Ellis, Can You
Dig It? Meeting Community Demand
for Allotments (London: New Local
Government Network, 2009) p. 13.

4
See for example
http://onthecommons.org/.

DAVID BOYLE

BLACKCURRANT SODA

Ingredients: Carbonated Water,
Blackcurrant, English Beet Sugar, Lemon

Best before: 08/02/15

A coach-load of pickers left Dagenham Library for
Feering Bury Farm in Essex to glean blackcurrants
on a hot and windy day in July. The fruit was sweet
and plentiful and everyone was keen to return next
year for another crop.

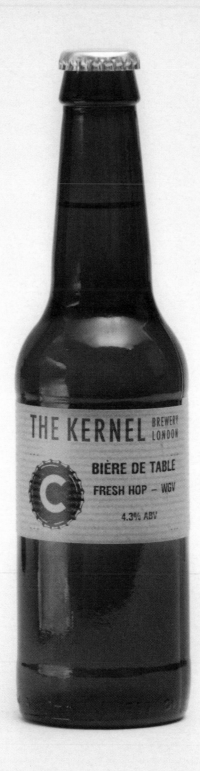

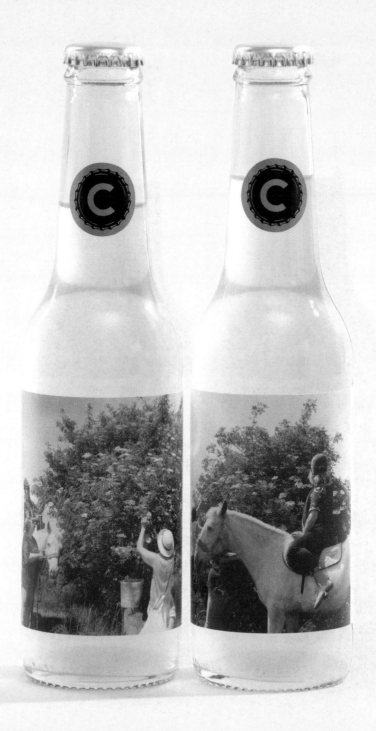

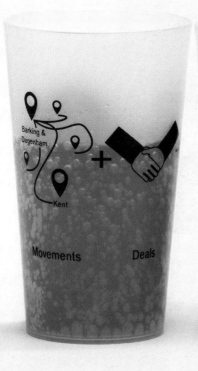

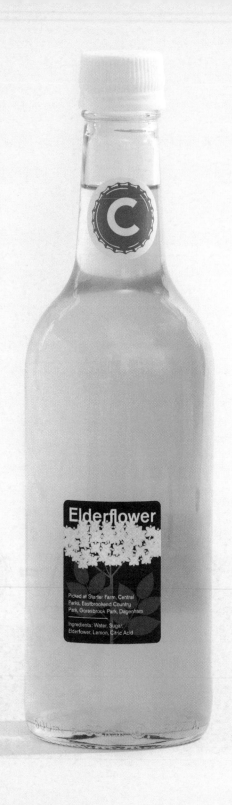

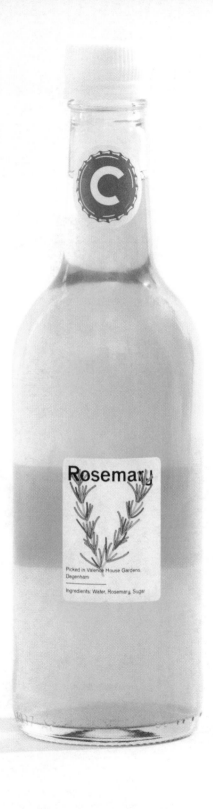

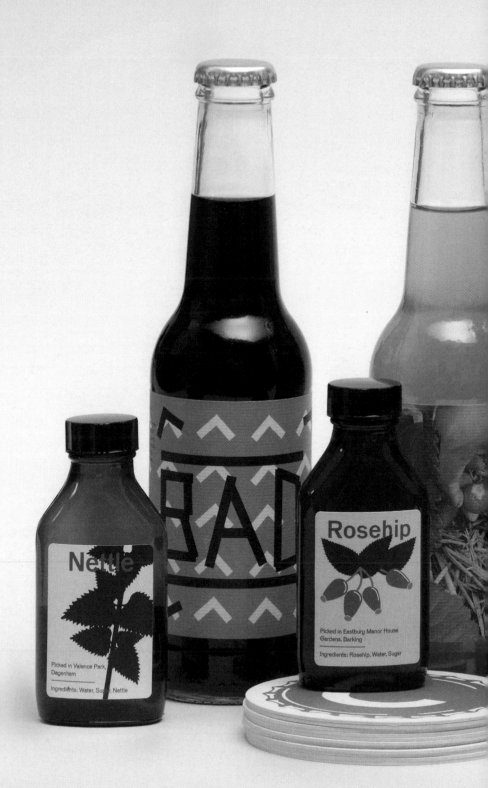

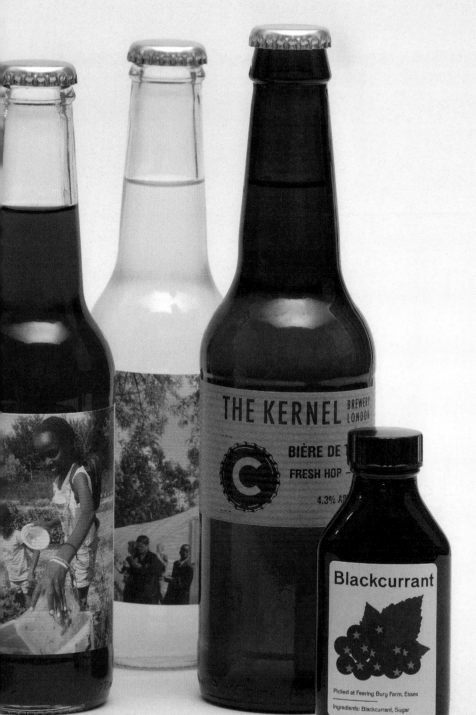

Company

Barking & Dagenham

Kent

Movements

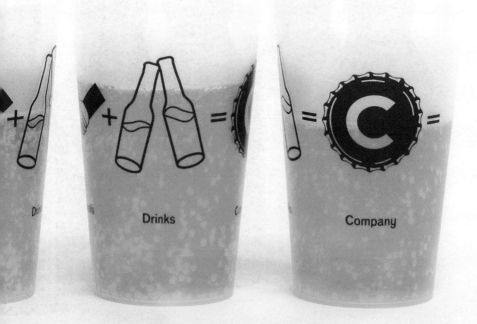

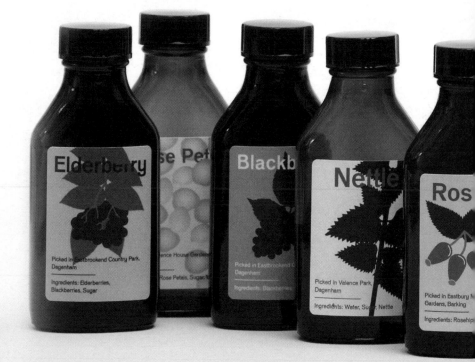

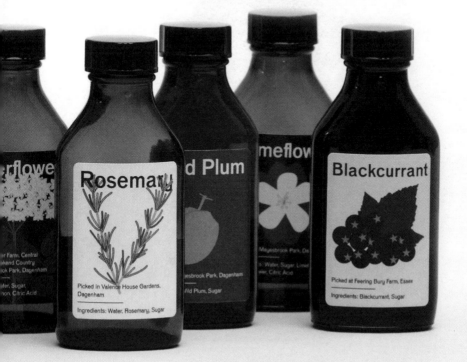

DEALS

Miranda Pope

Transactions and Agreements

While there are multiple definitions of the word deal, only one of its meanings is embedded in **Company**: that of a deal as a transaction or agreement between two or more parties for their mutual benefit. In this capacity, the deals in **Company** take on a variety of forms and social arrangements, many of them not mediated by money. They are formed through a myriad of interactions such as agreements, pacts, contracts, arrangements, gifts, negotiations and exchanges.

What does it mean to make a deal? As a form of social contract, a deal is always a point where relationships between those involved re-organize themselves, where changes take place in their social constitution, and where new systems might be established. All social groups and the modes of their relations can to a certain extent be thought of as being organized through various deals and what is included or excluded through them. Deals form, to a degree, the fabric of everyday living, in both informal and formal ways, on macro and micro scales – from local deals made daily with friends, relatives, colleagues and family, to international deals between corporations, governments, anti-government organizations and NGOs. Deals can therefore also be thought of as constituting a world-forming process. World-forming here is taken to mean that each participant in a deal has a specific socio-political relationship with every other aspect of the deal and hence occupies a place within a definable 'assemblage' that is created as a result.

In the context of **Company**, the deals that take place are firstly transactions that enable the structures of the project to happen, framing the contexts within which the project's activities take place. They can be understood as 'productive transactions', which is to say that they are productive in the sense that they set up situations in which activities and processes are able to happen, rather than because they produce anything in themselves (although this might also be the case).

The deals happen between a number of parties and for different reasons: there are deals for participation, deals for space and resources, and deals for funding. There are deals with collaborators, with the people who get involved in the making and doing and who are exchanging resources or knowledge as part of the project, for example local residents or non-residents with specialist knowledge to share. There are deals with organizations and co-funders such as the local civic authority (the London Borough of Barking and Dagenham) or Frieze Art Fair London and Kernel Brewery, who provide access to spaces where aspects of the project can happen. And then there are deals with Bank of America Merrill Lynch and Create for financial resources, who in return increase their share of what sociologist Pierre Bourdieu in **Distinction** calls 'cultural capital' – greater cultural authority through their connection with the project.

DEALS

Within these broad frameworks, each deal that takes place is a specific form of economic, cultural or social exchange. Classification is difficult as every deal that happens is its own discrete transaction directed by a precise combination of factors that pertain to the particular requirements of a situation within the project. Despite this – or because of this – each transaction marks out a set of distinct boundaries. These are the points where the involved parties and networks intersect and where the forms of the project emerge.

Deals as Structure

There are a number of observations to note about the deals. Firstly, in allowing the structures of the project to emerge, the deals assemble the project. They are integral to its architecture and framework. The project happens through the deals; each deal sets out specific courses of action, an intention towards a fulfilment of the activity put in place by the deal, with deals being continually negotiated in order for the project to move forward. In this sense, the deals can be seen as agents for change; they allow for situations to emerge where communities intersect or are re-organized, where activities (educational, recreational or experimental) are merged or deconstructed, and where new possibilities for co-operation between and within communities are fostered.

Secondly, the deals largely take the form of social interactions between individuals and groups of individuals. This is to say that they are neither formal economic transactions, nor are they mediated through another agency. Instead they are negotiated through the formation of heterogeneous relationships that take place in the social. There is no one dominant model of interaction, all the interactions respond specifically to situations and its needs.

Thirdly the deals also set up the spatial organization of the project. By this I mean to say that the places in which the project takes place are the result of deals that the artist has made with organizations that control access to the spaces, whether they are on public or private land. These spaces therefore become dependent on a number of negotiated injunctions, where an agreement has been made, for example, with the farmer not to disturb other crops, or the local authority to leave enough berries for the birds.

Finally, the deals also have a temporal aspect – they take place in time, they are altered through time and are dependent on time-critical factors. They are dependent on available plants, on crops, on the time lapsed between harvesting and producing. The deals are also simultaneously embedded in historical time, in the remembering of the multiple temporalities of the movements of working class communities in east London and the Barking and Dagenham area and the lasting impact this has on the communities there. These pasts are remembered through the project and rehearsed through its activities.

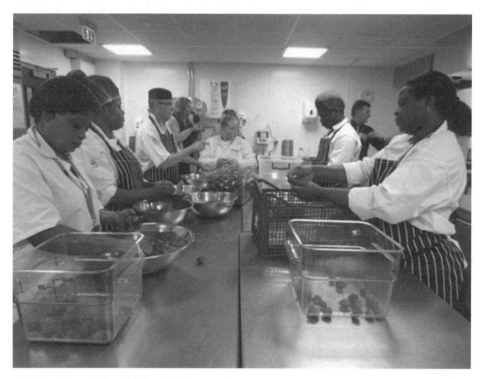

Left: Hulling the strawberries picked at Dagenham Farm, training kitchen, Barking and Dagenham College, June 2014.

Right: Cola concentrate making with Kate Rich, Dagenham Library, April 2015.

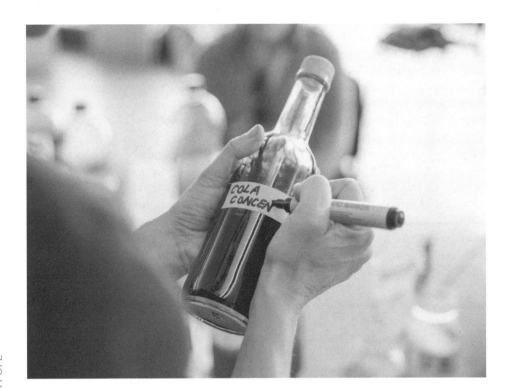

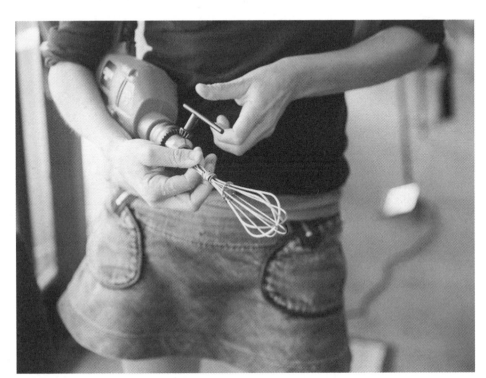

Converging

As the deals don't fall into existing structures of social activities and play such a central role in the production of the project's alternative socio-economic situations, it's helpful to think about their wider political implications. Felix Guattari's notion of transversality is a useful tool here to start to do this. First proposed by Guattari in **Chaosmosis**, and central to his thought and psychoanalytic practice, the idea explores ways in which alternative radical subjectivities can be produced by confronting existing social and political separations and limitations. Through the transversal new connectivities aim to produce models of subjectivity that are, as he says, 'more operative within modified assemblages, more open, more processual, more deterritorialized'.[1] In **The Three Ecologies**, Guattari reiterates the importance of transversality in helping to address problems relating to the environmental crisis, which for him is endemic to capitalism and inextricably linked to other social and political affects of capitalism.

Transversality can be understood as a breaking-through of the boundaries of existing social and political separations and limitations to identities, in an attempt to undermine the structures that maintain current limitations, inclusions and exclusions. It can be imagined as a mode of being in a state of continuous rupture and breakdown of the boundaries defining the hierarchies and logics of society. In **Company**, these shifts might be seen as a result of the multiple community activities instigated through the deals. They take place outside normative structures, bringing participants together within spaces on the project's terms, which may shift as the activity changes. The result of this process for Guattari is a constant state of production of new alliances and modes of being, meaning that: 'social ecosophy will consist in developing specific practices that will modify and reinvent the ways in which we live as couples or in the family, in an urban context ... it will be a question of literally reconstructing the modalities of "group being" ... through existential mutations driven by the motor of subjectivity'.[2]

Because it is continuous, the transversal mode of being does not offer any closure. In this sense **Company**'s activities might by-pass traditional institutional structures (in education, or in terms of the presentation of art), or ask new things of an institution or the subject as collaborator or participant, and the artwork becomes dispersed across new areas of possibility with alliances and actions being continually negotiated through the practices of drinks production itself.

Deals as a Mode of Performativity

This negotiation of possibilities within the project is also a process by which informal economic and social cycles and rhythms of the project are given form. This can be understood as a performative process because the making of the

deals configures relationships within the project and forms its structures. Performativity here is not used to suggest that the project's participants perform the deals or subsequent activities for an audience. Rather, it is to say that the deals are actions that create form in and of themselves. The origins of this meaning emerges from J.L. Austin's writing on 'performative utterances'3 where he focused on phrases used in speech acts, which perform what they were stating, as opposed to describing their content, and that 'could not be true or false'.4 Examples of this were things like saying 'I promise' or 'I do' – they were an enactment by the individual at that moment. It was something they were doing through the act of speech, rather than being a statement of something they intended to do.

The deployment of this definition of performativity is most well known through the work of Judith Butler, who has used it for a discourse that questions ways in which gender is produced through an iterative performativity of norms and codes. The breadth of her focus has recently expanded to include economic concerns and in her essay **Performative Agency** she looks at how notions of performativity might operate to create and maintain divisions between economic and political forces.

Her argument contends that the existence of the market and the economy can be understood through practices that 're-constitute the idea of the market as an existing and autonomous reality'5 and that equally maintain the idea of the market as much as the activities of the market. These practices or processes, she argues, may sometimes be 'errant', such as those that were central to the 2008 financial crisis, and it is these that can call the existence of the market into question.6 Crucially, in relation to **Company**, she also argues that these reiterative practices we understand as being of the economy have been separated from the social and that 'when everyone turns their attention to what is called the "economy", the interpretive procedure enacts and re-enacts a selective process by which broader social and symbolic meanings are separated off from the economic thus producing the effect of the ostensible autonomy of the economy'.7 This distinction between the economic and the social is, for Butler, 'performatively produced through a process of selection, elision, and exclusion'.8

So in Butler's terms the iterative practices that are separated from the social are those directly relating to the dominant modes of economic practice that maintain the flows of global capital and which are carried out through the key economic institutions like banks and corporations, the IMF, the Federal Reserve etc. 'Such performative practices could be anything from an act of speech, but other practices could be: mundane and repeated acts of delimitation that seek to maintain a separation among economic, social and political sphere'.9

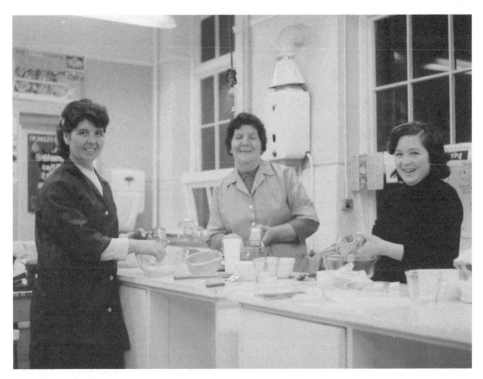

Domestic Science evening class at Eastbury Secondary
School, 1966.

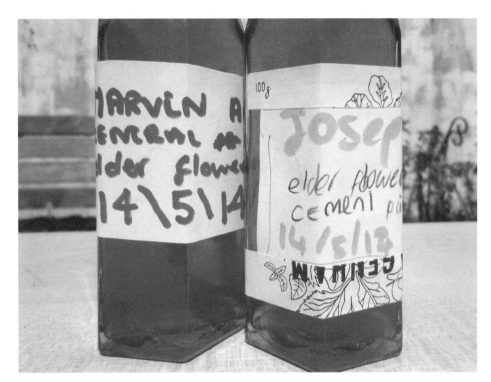

Labelling the elderflower cordial made during workshops
at Dagenham Farm, May 2014.

What is important to note here is that while **Company** is performing what we could call emancipatory economic practices, they are not the practices that Butler deems economic, rather they are practices that she contends are separated from the economic, that fall in the realm of the social. In contrast to what she is saying, through the fact of highlighting the performative nature and structures that have contributed to the production of economic systems, Butler actually demonstrates how economic practices are equally produced through social activities.

This question of alternative economic practices as being produced through the social, and how they relate to mainstream neo-liberal economic structures is central in the work of J. K. Gibson-Graham, who explores the constitution of economic practices without differentiating between the economic and the social. Gibson-Graham starts from a position of the worldwide economy being 'insufficient for the task at hand', and questions the use of seeing it as the 'centrally organising cultural frame'.**10** For Gibson-Graham, the notion of economy is concerned with rethinking 'economic identity and economic dynamics'**11** with the purpose of looking at how diverse non-mainstream economies can contribute to the construction of a model of a community economy. To do this, Gibson-Graham aims to 'rethink the economy from the ground up' by reorganising economic practices to do with 'material survival' into a single flat topography. There are five types of economic practices: enterprise, labour, property, transaction and finance. They are organized according to their dominance within the 'mainstream economy and unques-tionably included in representations of the economy'.**12** Below the dominant practices she places those that lie outside mainstream practices, some of which might not be immediately thought of as economic practices. The social relations that instigate these practices are much wider than in mainstream economic practices, and include things like 'trust, sharing, reciprocity, coop-eration, collective agreement, thrift, love, community, pressure, social justice'.**13**

Gibson-Graham's work also goes further than Butler in terms of rethinking the performativity of capitalism, suggesting that these non-mainstream practices are already performing alternatives – what she calls 'performative ontologies', or 'world-making' practices.**14** Performative ontologies for Gibson-Graham are the social, ethical and political practices that rearrange and transform existing configurations through collective, negotiated activities. They are ontologies of 'economic difference' or 'diverse economies'.**15**

Gibson-Graham argues that these ontologies of difference are inextricably linked to knowledge, because investigating and understanding alternative economic practices allows for a 'different imaginary in which economic possibility proliferates'.**16** In order to set up world-changing practices, says Gibson-Graham, the distinction between epistemology and ontology needs

to be collapsed, to produce a 'thinking practice'. Rather than this being practical applications of concepts, a thinking practice means economic, or social or community activities that rethink economy as a site of 'ethical interdependence' rather than being 'capitalocentric'.17

Performative ontologies are first and foremost experimental economic activities that are processed as part of an attempt to disrupt the notion of a 'capitalist' economy. Her aim is to: 'dis-order the capitalist economic landscape, to queer it and thereby dislocate capitalocentrism's hegemony'.18 She aims to unsettle the idea that there is a single economy, so performative ontologies become experimental claims for other worlds, for alternative forms of organization that set up heterogeneous spaces of socio-economic possibility.

Such practices of 'world-forming' embedded in Gibson-Graham's concept of performative ontologies involve practices of collective negotiation and partitioning, and are hence inherently ethico-political. Seen in this context, the new economic structures that are formed through the deals and resulting activities of **Company** could be said to share these characteristics of her notion of performative ontologies. They set up possibilities for a new articulation of an experimental community economy, which is informed simultaneously by historical, conceptual, spatial, geographic and temporal – and hence episte-mological – features. The execution of deals done by the artist and her collaborators initiate moments that merge local, scientific, economic and historical knowledge to take place, for histories to be remembered, ingredients to be gleaned or foraged, knowledge to be shared, and drinks to be tested, produced or distributed.

The deals that instigate and perform structures of **Company** are world-making on two counts: they are contributing to the development of a community economy, and they are also agents that work to define an art project. They create points of acknowledgement where the project as art and social activity is acknowledged. They therefore perform twice, rearranging socio-economic relations and the relationships between art and the social. In this sense the activities of **Company** can be said to constitute performative ontologies.

But considering the art project as being drawn through its deals also perhaps helps to widen their implications beyond just their performativity. In order to do this, the deals need to be thought through at their moments of constitution. That is to shift the focus onto the actual processes of interchanges that take place within the deal, to acknowledge the entities and issues involved, and to continuously 'hold' open the question of what becomes part of the activities and what is excluded. To look at what is actually performing. This might mean something like acknowledging the limits of the elderflower picking to make

Left: Preparing for Cherry Blossom Ade production,
Square Root Soda Workshop, Hackney, May 2015.

Right top: R. White's soft drinks stall, photo from Tony
Clifford's essay 'The Secret Lemonade Drinker: The Story
of R. White's and Successors in Barking and Essex', 2014.

Right bottom: Company Drinks bar, Barking Folk Festival,
July 2015.

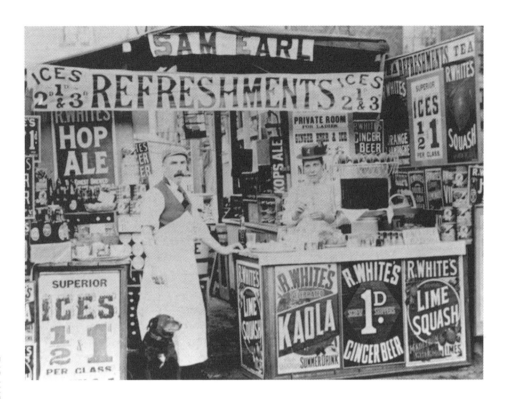

sure there was enough for the birds, or it might mean unpicking the more complex connections that link the Frieze Art Fair to the hops that were picked in Kent, or equally it also means acknowledging that elderflower has medicinal uses in addition to a drink ingredient, for example, or other practices and knowledge of which only fragments remain.

What this means is that as well as their moment of completion, the deals also need to be considered in terms of being the material of the project. The materiality of the deals might include the conversations and activities that arise through the deals, but equally it might also take in the materials of the project, the plants, flowers and herbs, the land and by extension its other uses and users, and the ways in which they are implicitly intertwined in the project through each deal. Such materials continue to exist outside the project and this constantly bears down on the ways that they are put into place through the activities activated by the deals.

While objects like the drinks and ingredients within the project have been taken up as actors in a previous essay, it is worth commenting here on the state of these materials in slightly more precarious terms. By precarious, that is to say that the constituent materials can be thought of as not being entirely captured through the project, or only being partially included. There is always something of the materials leaking out, always an excess, something that has an independence beyond human agency. This idea can be examined by Jane Bennett's notion of vital materialism, an idea whose political goal is framed as 'not the perfect equality of actants but a polity with more communication between members'.19 For Bennett, vital materialism is a way of thinking the agencies of non-human actors, and taking into account their independent capabilities and agencies. In this context, the deals and their resultant activities might therefore become in Bennett's terms 'lively and self-organising with an affective speaking human body not [being] radically different from the affective, signalling nonhumans with which it coexists, hosts, enjoys, serves'.20 The deals are simply collections of such materials that become included in the social space within which they take place.

But how does this play out in the project as an artwork? It is helpful to address this final question of this essay by looking at Gregory Sholette's essay 'After OWS: Social Practice Art, Abstraction and the Limits of the Social' in which he suggests that Bennett's notion of vital materiality can introduce a 'thingness' into what he calls 'social practice' art – art practices that take place within and construct the social. This idea of thingness can act as a way of marking out the social limits of such practices; they can be 'abstracted' in their materiality as such.21 By doing this, he argues, the focus can be shifted away from socially-engaged practice as being perceived as 'a strategy for unlikely survival against the forces of neo-liberal enterprise culture and its strip mining

of creativity'.22 Instead, socially-oriented critical practices become tools that can engage with the boundaries of the social practice within the social itself.23 In terms of **Company** and its deals, the boundaries of the practice as instigated through the deals are points where what constitutes the artwork is always being questioned by the possibilities offered by the framework of the project as a drinks enterprise.

Therefore, the project pushes Sholette's proposition further, as within the wider social context that the project occupies, its limits are continually being shifted as new deals are made. The deals do not represent closed points of interaction as such; they are open and porous in terms of the possibilities of its constituent activities – and also because of the contingencies of its materialities, because of things like the weather, crops, harvest and participants. The boundaries mark out a materiality in the resources used and ultimately drinks produced into which the deals are inscribed. As Sholette says, we need to recognize not only the role of extra-human technologies and abstract concepts like democracy, but also the corporeal presence of 'nature', not in some sugary, universal form, but as a negation that radically confronts human culture with alterity'.24 In **Company**, this radical confrontation might be understood in terms of the ways in which the deals negotiate the continuous and essential relationships that the project has with elements of 'nature'. As the deals produce, reproduce and reset multiple configurations of entities and socialities that become a kind of ongoing archive of transactions, they demonstrate that such radical alterity constitutes a constantly shifting set of possibilities bound by the contexts they inhabit at points in time.

NOTES

1
Felix Guattari, Chaosmosis (Sydney: Power Publications, 1995) p. 61.

2
Felix Guattari, The Three Ecologies, (London: The Althone Press, 2000) p. 34.

3
John Langshaw Austin, How to Do Things with Words (London: Oxford University Press, 1962).

4
Ibid. p. 70.

5
Judith Butler, 'Performative Agency', in Journal of Cultural Economy, 3:2 (2010) p. 148 [pp. 147–161]. Available at http://dx.doi.org/10.1080/17530350.2010.494117 [accessed 18-06-2015].

6
Ibid. p. 148.

7
Ibid. p. 149.

8
Ibid. p. 149.

9
Ibid. p. 150.

10
J. K. Gibson-Graham. 'Rethinking the Economy with Thick Description and Weak Theory', in Current Anthropology, Vol. 55, No. S9, Crisis, Value, and Hope: Rethinking the Economy (August 2014), p. S147 (pp. S147–S153). Available online at http://www.jstor.org/stable/10.1086/676646 [accessed 18-06-2015].

11
Ibid. p. S147.

12
Ibid. p. S149.

13
Ibid. p. S151.

14
Ibid. p. S149.

15
J. K. Gibson-Graham, 'Diverse Economies: Performative Practices for "Other Worlds"', in Progress in Human Geography 32 (October 2008) pp. 613–32. Available online at: law.uvic.ca/demcon/victoria_colloquium/documents/gibson_2008_progress_paper.pdf, p. 2 [accessed 18/06/2015] and http://phg.sagepub.com/content/32/5/613.full.pdf+html [accessed 18-06-2015].

16
J. K. Gibson-Graham, 'Rethinking the Economy with Thick Description and Weak Theory', in Current Anthropology, Vol. 55, No. S9, Crisis, Value, and Hope: Rethinking the Economy (August 2014), p. S149. Available online at http://www.jstor.org/stable/10.1086/676646 [accessed 18-06-2015].

17
Ibid. p. S152.

18
J. K. Gibson-Graham, A Post-Capitalist Politics. (Minneapolis, MN: University of Minnesota Press, 2006) p. 77.

19
Jane Bennett, Vibrant Matter: A Political Ecology of Things (Durham, NC: Duke University Press, 2010) p. 104.

20
Ibid. pp. 116–17.

21
Gregory Sholette, 'After OWS: Social practice art, abstraction and the limits of the social', in e-flux 31 (January 2012). Available at: http://www.e-flux.com/journal/after-ows-social-practice-art-abstraction-and-the-limits-of-the-social/ [accessed 18-06-15].

22
Ibid. p. 7.

23
Ibid. p. 7.

24
Ibid. p. 6.

A MAN IN A GREY SUIT: ART FOR MUNICIPAL PLACES

Marijke Steedman

In 2014 Create commissioned Kathrin Böhm with Myvillages to develop **Company: Movement, Deals and Drinks.** Create worked closely with them to realize the project. The Project was set-up with funding and support from the London Borough of Barking and Dagenham (LBBD).

Create commissions new art in east London, where in the post-war era large numbers of artists and creative organizations have settled due mainly to the relatively low cost of housing and workspace. Create addresses the apparent disjuncture between the creative activities of these communities and the lives of other people living in east London. Create has no fixed public space and the projects tend to be driven by issues and often hinge around collaborative processes.

Since their inception in 2009, Create has developed a body of work that inevitably reframes the notion of 'public art' to explore possibilities for public ownership of art. Create works closely with local authorities to develop infra-structure to commission and support art in east London. Within this terrain the role of staff in local authorities and the degree to which they engage in critical discussion about the place for art is crucial.

Company: Movement, Deals and Drinks is a remarkable project not least due to the approach of Kathrin Böhm and the art collective Myvillages. **Company** is a complex social, economic and aesthetic network stretching from Barking and Dagenham and beyond. The project contests demarcations of where art can exist and how it is embodied as art slips disarmingly from economic transaction to public health service into manufacturing process.

The London Borough of Barking and Dagenham is on the edge of east London. One hundred years ago the area was predominantly rural. It underwent a massive inter-war building programme resulting in the largest council housing development in the world. Large numbers of working class communities from London's East End settled in the area and as a result the area has a uniquely rich working class heritage. Like most Outer London boroughs, the area has more recently become home to new migrant communities. Until during the last decades the area had a limited infrastructure for cultural activity, with few cinemas, galleries, museums or theatres, and local people have described experiencing a sense of dislocation from the rest of London.

Company is a public art project in the sense that it is partly owned by a public body, and in turn is owned by the residents of the London Borough of Barking and Dagenham (LBBD). When **Company** was commissioned in 2014 it coincided with a period of unprecedented national cuts in funding for public services – in 2012, to enable a balanced budget to be set, the LBBD took the difficult decision to cut its arts development and events teams and with it the revenue

budgets for this activity. Within that context the decision by LBBD to fund a major art project was remarkable. Added to that the decision to support an art project driven by social concerns and conceptual processes, with no object-based outcome was notable.

In order to explore this area further I interviewed Paul Hogan, the Divisional Director for Culture and Sport with Barking and Dagenham Council, about his role and that of LBBD in the **Company** project. To some extent this was motivated by a desire to heroize the role of the local authority at a time when the UK public sector is ideologically under threat.

The interview set out to acknowledge the work already taking place in public services that made it possible for **Company** to exist, as it does, outside of traditional art contexts. What did the council bring to the project? What is their philosophical take on the project? How does Hogan's role compare to that of the private art patron, or the curator?

LBBD is what might be termed the 'hidden producer' of **Company**. In order to fund the project, they were active in finding a critical frame to justify the project, enabling it to sit within existing services and networks in the borough. While the artist and the curator grappled with the meaning of the work, the council also tackled fundamental questions about the role of the artist and function and legacy of the artwork. The decision to support **Company** indicates a conviction from LBBD that art should be commissioned within the context of public services. What hurdles are scaled in order to assert this conviction?

Kathrin Böhm is critically aware of instrumental concerns entering into the project from outside. A large part of her role is to determine when those concerns should be embodied within the project and when they should remain outside in order for the project to challenge existing approaches or to propose new ones. In parallel LBBD have specific instrumental objectives for **Company** that they seldom articulate in relation to the artwork. What are these terms for LBBD? How does the council navigate the concerns of the artist whilst meeting their own objectives for the work?

It's likely that the pulls of intention from Böhm and Myvillages, LBBD and Create contributed to its dynamism and energy. Each simultaneously adopted and subverted the instrumental concerns of the other creating a work that embodies the complex public and municipal context for the work. This kind of commissioning is important for art and artists as a space to make work beyond the glare of the marketplace, and to reconcile their social, political and aesthetic concerns with communities outside of the art world. The municipal environment reflects the complexities of our contemporary political world and is in equal measure rewarding and infuriating as a context for making new art.

MARIJKE STEEDMAN

Marijke Steedman How were you involved in making **Company: Movement, Deals and Drinks** happen?

Paul Hogan One of the really interesting things is how this has been funded. I was able to find money in the public health budget, because we don't have an arts and events budget in the council. That was cut, and all the staff associated were cut in recent budget rounds. So we are an organization that in some respects is incredibly rich, and in some respects is incredibly poor.

One of the big challenges for me is celebrating and really maximizing what we can do with what we've got. With this case, it was a very simple case to make to colleagues in public health about the kinds of benefits that this project would bring. So they committed a one-off grant from the public health grant.

There is a whole range of resources that we've deployed to support the delivery of **Company**. About four or five or six distinct council services supported the development and delivery.

MS What is your personal role in the London Borough of Barking and Dagenham?

PH On the face of it, I'm very much a grey man in a grey suit. Within a local government environment, that's incredibly valuable, because it means I can broker things and make things happen. I can find routes through the council, because a lot of artists have told me that local authorities can be impenetrable.

Often, my role is to bring a cultural perspective because that's what transforms a place. The opportunity for people to participate in the arts and creativity is transformational.

I get it. I'm steeped in practice from university and the work that I've done, so I totally get it. I don't need to be convinced.

MS Can I find out more about that word, transformation? What does transformation mean in relation to, for example, what Kathrin has been doing?

PH Actually, it's an opportunity to say to people that their experiences, their life history, really matter and also that people have opportunities to be stretched. With the Myvillages project, it's amazing the number of people I meet who have been engaged by it and talk about it.

It's how that moves out across the borough. The more opportunities there are for people to have that experience, then the better it is for a borough like ours.

It's such a transient population, and there are such issues in terms of the rapid demographic change in the borough. It's transformational because it can bring people together across the community. Art is one of the very few vehicles where that can work in an incredibly constructive way.

MS Can you talk about the open-endedness that you can experience when you're working with an artist? You can't be absolutely certain that they're going to deliver, on message, exactly what it is that the council wants them to say?

PH You've got to take a risk, yes. Sometimes, you can't dabble; you've got to let it run its course. So once you've decided to go for it, you've just got to let it go. That can be quite scary. The easy thing to do is not do it, but sometimes you do have to do it.

MS Is it useful to you that artists can often ask surprising or difficult questions?

PH It depends on the context. It really does. Quite rightly, the artist's work is important in its own right, and it may be all that's important, actually. That wider community engagement might be totally inappropriate or not relevant, depending on the nature of the programme.

We are unashamedly focusing on the instrumental value, absolutely, and that's what we're interested in.

It depends on what the message is. For instance, Chad McCail's mural (commissioned by Create in 2014) which touches on the history of the British National Party in the borough, that's a difficult issue but acceptable. That's the issue, there are some things which may well be unacceptable and that's a big challenge to get around.

I don't think we are as open and willing to take that one on the chin as perhaps we should be. I'm not sure we're mature enough as an organization to do that.

MS Why specifically does it matter that an artist led **Company**, rather than someone specializing in community development?

PH Because of how she brought people together and how she went about doing that and that's the difference. The opportunity for people to come together in a way that is respectful and enables people to grow and develop in a way that makes sense to them. People have come with her and gone off in lots of different directions and it's been a catalyst for change, I suppose, that's what it is.

MS Where do you think art ought to exist?

PH It's the footfall and the kind of people who get exposed to it. I don't want to be dismissive about people's viewing habits, but the likelihood is I would suggest that many people wouldn't set foot in a gallery or see it as a place for them, but they are seeing art in another setting.

And in the case of **Company**, art outside of a gallery can relate a lot more to the culture of Barking and Dagenham. People are very proud of it and want to see it acknowledged and shared and understood.

There is so little opportunity at the moment in the borough. What we need is more opportunities for people to actually see the arts as a viable proposition for them, in terms of work and also something that should naturally be part of their normal day-to-day living as well.

MS What prevents people from experiencing art?

PH Within Barking and Dagenham there are two main issues. One is education and one is cultural. Because of the issues about demographic change in the borough, what we've not done is really make sense of which cultural activities are actually taking place in people's homes and on people's doorsteps. It's actually absolutely thriving. Who knew?

I think there is also a cultural issue. We in the council have a very traditional understanding about what creativity and cultural engagement is. We are missing a big trick, I think.

MS I find **Company** exciting partly because it is complicated to describe in art terms. How do you describe the project?

PH What you do is you have a different story depending on the audience and you shape it accordingly. For the councillor who is responsible for public health, it's all about the health and well-being benefits of this. It genuinely touches on so many agendas that you can shape your argument, and a very credible argument, to fit the audience and that's what we do.

MS Ultimately, who does **Company**, the project, belong to?

PH It's its own entity. We've done our bit and it's on its way now.

I think it changes over time. I'd have said a year ago it was very definitely a council project and now it's definitely not. It's an art project in its own right. It will now be interesting to see how things develop with local people.

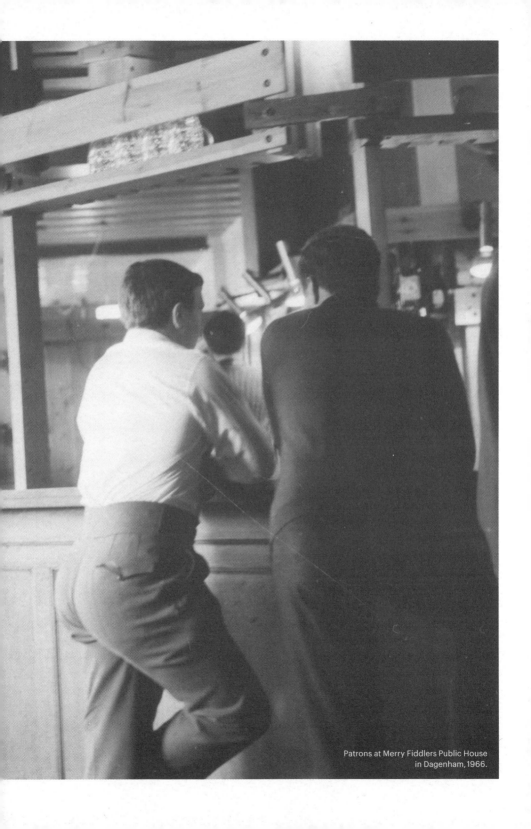

Patrons at Merry Fiddlers Public House
in Dagenham, 1966.

DRINKS

Miranda Pope

The Role of Drinks as Art Objects

The drinks are the most publicly visible objects of **Company**, and as such are emblematic of the artwork. They embrace the project's social and historical trajectories, its activities and workshops, capturing individual and collective narratives of going picking and drinks production, of migration, labour, the technologization of rural practices and new practices of commoning.

The choice of drinks produced is based on the plants and flowers available locally throughout the season. In 2014 and 2015, cordials and concentrates were produced from things like elderflowers, blackcurrant, blackberries, elderberry, rosehip, wild plum and rose petals. Carbonated drinks included Cherry Blossom Soda, Flowering Currant Soda, Strawberryade, Elderflower Lemonade and Blackcurrant Soda. The only drinks produced from ingredients not sourced local to Barking and Dagenham were the cola and the beer. The cola concentrate was made locally but with ingredients pre-sourced elsewhere, and the beer which was a blend between a standard Bière de Table, mixed with the fresh green hops hand-picked during the annual **Company** hop picking trip.

The drinks are also representatives of the project's status as art, perhaps even being perceived as art objects in their own right. However, if the drinks become art objects in their own right, the processes and activities through which they are produced are relegated to 'support acts' that bring them into being. And in **Company**, this is not the case. The activities and workshops are part of the artwork, existing on equal terms with the drinks, as they do with each other. In this case, how do we understand the project's art status as a whole? How do we think of the artwork and community activities as existing simultaneously, rather than the drinks simply embodying these rearrangements of histories, activities and communities? The drinks therefore appear to be at the centre of an ontological conundrum at the point where the social and the commercial merge. They are, after all, the things that are on display and available for purchase when the project is presented in contexts exterior to the ongoing activities of the project, and they are often displayed in art world related contexts – for example at the bar at Frieze Art Fair – and they do a lot of 'PR' for the wider activities of the project in these contexts.

As previously outlined, multiple relationships to the social are embedded in the drinks. **Company**'s remembering of the social history of hop picking happens through the setting up of social activities within Barking and Dagenham and its surrounds, which produce social effects and changes within the community, as well as contributing beverages to local social events. In constructing these invisible social structures, **Company** presents the possibility for a more complex reading of artworks that sit within an ongoing tradition of collective and social practices of making and doing can be and do.

Taking this as a starting point, this essay looks at how the project's status as art plays out and where the drinks fit in to this. It aims to articulate a position where the project is seen both as art and as a set of social activities existing in tandem. By this, I mean that the project shouldn't be understood as having two statuses. Rather, its artistic and social statuses are interwoven, both equally contributing to the project's manifestation at the same time. To explore these ideas, the essay will look at ways that the conditions of the project and its constituent elements function, and how this produces an interconnected set of aesthetic and social arrangements that are not easily disconnected from each other. They are not, however, seen as split into a 'double' ontology – where art ontology and social ontology exist apparently equally. This is because such a split is never straightforward and always governed by political hierarchies in the relationships between the social and the aesthetic, where the aesthetic is always prioritized.

The Co-Existence of the Social and the Aesthetic

Rather than the artwork being perceived as operating simultaneously as two things, it operates through a wider political framework. This framework has a status as an experimental participatory project that exists through its social and economical structure – a determinant set of circumstances that also experiments with an alternative system of drinks production. It is not, however, setting out to create what Brian Holmes might refer to as a conscious 'post-capitalist' art project1 but rather it is initiating and stewarding conversations about how such enterprises might be set up, and how they can introduce new networks of activity in spaces where public gatherings are able to take place.

How therefore is the project defined and what kinds of ontological categories does it fit into, or, does it in fact evade ontological capture altogether? By responding to invitations to join social situations that frame the structure and the production of the drinks, the drinks come to address issues to do with branding, visual identity, image production, multiple authorship, collaborative working, and small-scale production processes. They therefore exist within far broader critical parameters.

As social products, the drinks can be understood both as objects around which groups of individuals coalesce, and as products that produce communal and social effects. As objects existing equally through social and aesthetic criteria, it might seem straightforward to think of the drinks as operating in terms of Rancière's notion of the 'sentence image' in **The Future of the Image**. Here he proposes that combination of two functions that are defined aesthetically – text and image – merge and overturns both their agencies to create a more equivocal ambivalence within the artwork. However, for Rancière the artwork exists in a state of oscillation between its aesthetic and social realities – they

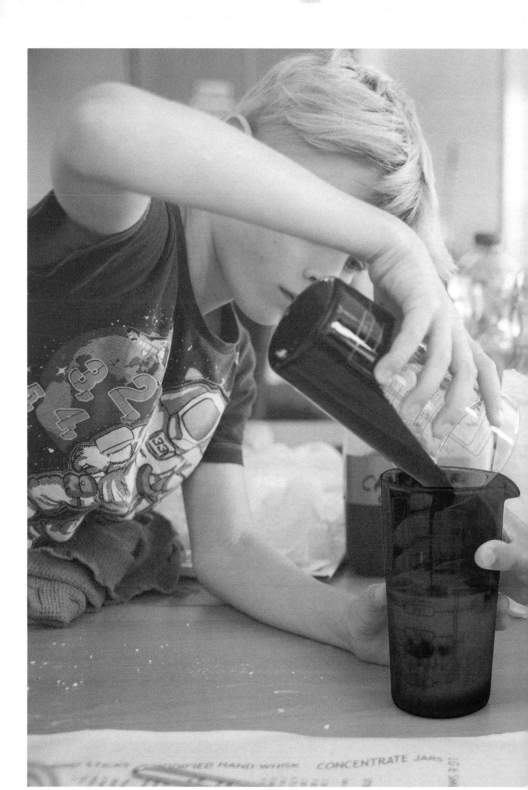

'co-belong' within the artwork,2 and the drinks in **Company** and its wider activities operate in much more nuanced ways.

This is because the drinks are always tied back to the wider situations within which they are produced – the workshops, foraging trips and conversations – and are not solely the artwork. While they might be the focus of the project when it is being presented outside of its contexts of activities, they do not act as intermediaries in these situations, nor do they move between two states of being. They might better be thought of as 'integrated spokes-goods', still an inadequate expression, but it goes some way to capture their multiple roles of making statements and representing the project on behalf of its wider activities. They are a part of the artwork, and in their most straightforward incarnation are simply beverages, and buying and drinking them does not make a critical comment on their being part of a work of art or of the purchaser participating within the work of art. This situation might be seen in contrast perhaps to the limited production of a Tue Greenfort-initiated mushroom dish served up in the South London Gallery's café during his exhibition **Where The People Will Go** in 2011. It was made with mushrooms produced as part of the artwork, **Oyster Mushroom Production (Mycorrhiza)** shown in the exhibition, where the mushrooms were grown in sacks filled with the café's waste coffee grounds.

Defining the Drinks

If the drinks cannot be understood as existing in a Rancière-ian 'oscillation', how can their status as artwork be formalized in a different way? To address this it's helpful to think about alternative conceptions of how art might be thought of, and to concentrate on how the social limits that frame the realization of **Company**'s concepts also generate its aesthetic limits. The aim is to demonstrate through the artwork, as Brian Holmes might suggest, 'that there are other ways of unfolding formal complexity into lived experience'.3

The task of unpicking the ontological conundrum of the aesthetic and the social within **Company** begins by thinking about what constitutes the nature of the conditions under which contemporary art is produced, and how art itself might be understood within these contexts. This will be done through two, slightly divergent, theoretical approaches that address the complexities of the various situations within which art is produced today. Firstly, I will look at philosopher Peter Osborne's notion of contemporary art being 'post-conceptual' as opening up an alternative space for understanding the expansion of aesthetic and social boundaries of art. Osborne's ideas are useful here to clarify the importance of the notion of the contemporary in relation to art. I will suggest that **Company** presents a contrast to what Osborne calls the fiction of the contemporary, suggesting that perhaps not all art produced

today is contemporary in this way. I will do this by looking at how, with its expanded boundaries continually happening in real time, the project might be better understood through theorist Stephen Wright's idea of the 'de-ontologized' artwork.

Post-Conceptual Art

Osborne's thesis sets up the notion of the 'post-conceptual' as convergent conditions under which artworks are produced today. The post-conceptual artwork, Osborne argues, is defined through six conditions: a 'necessary conceptuality'; 'a necessary – but insufficient – aesthetic dimension' in the form of some kind of materialization; 'an anti-aestheticist use of aesthetic materials'; expanding 'to infinity' the possible material means through which art is produced; a unity within its multiple forms of materializations that is 'irreducibly relational', and an historical flexibility embedded within the borders of the work.4

Osborne's idea of the post-conceptual is therefore predicated on the notion that all art has an 'ineliminably' conceptual aspect that operates in conjunction with its necessarily aesthetic aspect to produce the logical and temporal consequences where the boundaries of art are infinitely and temporally fluid. This idea of art as being post-conceptual – spatially and temporally fluid, with expanded aesthetic boundaries that can be manifested in many different forms – is one that appears to present a straightforward paradigm for Company. However, if we look more closely, Osborne is concerned with contemporary art as being post-conceptual art, and so in order to fully understand how this can enhance a critical context for Company, the idea of the contemporary needs to be explained further here.

Osborne suggests that the contemporary is an idea that is used to create a unity of what are essentially disjunctive times: 'the coming together of the times of human lives within the time of the living'.5 Two problems arise here, as he points out. Firstly, the present itself is not given in experience as such, since it only exists as the differentiation or fractured togetherness of the other two temporal models (past and future) under the priority of its futural dimension.6 So the contemporary is actually a projected idea of a horizontal unity, according to Osborne. Secondly, there is no one single unity or horizon, no shared position which could cohere multiple experiences into a whole, or a totality, or complete form, but this, Osborne argues is how the contemporary operates, as a utopian idea that equally disavows itself at the same time. So expressing the contemporary through a singular vision at the time of the present is a logical impossibility meaning that the notion of the contemporary represents a fiction, replicated through the unity of the artworks themselves, as its symbolic manifestation. The contemporary artwork hence also operates through this fiction.7

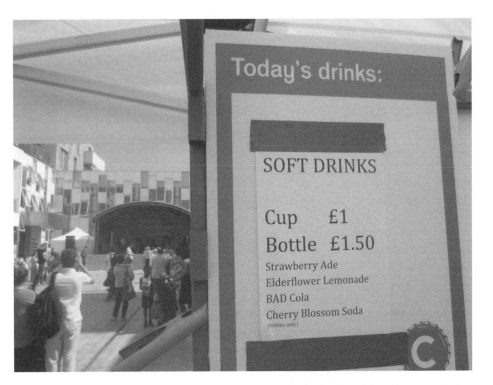

Today's drinks:

SOFT DRINKS

Cup £1
Bottle £1.50

Strawberry Ade
Elderflower Lemonade
BAD Cola
Cherry Blossom Soda
(bottles only)

C

Left top: Company Drinks bar at Barking Folk Festival,
Barking Town Square, July 2015.

Left bottom: Company Drinks Bar at Frieze Art Fair, Regent's
Park, London, October 2014.

Right: Enjoying a beer after the picking, hop picking trip
to Kent, September 2014.

The problem that arises for **Company** is that this notion of the post-conceptual sets its limits through the imaginary horizon of the contemporary, whereas **Company** doesn't focus on setting limits in fictional terms, its limits are set by actual possibilities allowed by its activities in real time. The project operates through being embedded within an existing set of social realities connected to actual circumstances in real time and ambitions of its participants, without irony or artifice. Its expression is fragmented in terms of where and when it takes place, but it is not trying to conjoin the multiple activities that constitute it into a horizontal unity, rather it is attempting to unify them into an experimental reality. Indeed, even its name expresses the presences of multiple possibilities that its transactions continuously enable in time and space. So while the project seems to concur with many of Osborne's conditions that define the post-conceptual, it actually presents an alternative version of art to that inscribed in the fiction of the contemporary proposed by Osborne. It is a counter to this fiction. So while the contemporary might be understood as 'a living, existing, occurring together "in" time',[8] of different but equally present times as a historical unity, in **Company** this does not happen by creating a fictional unity out of the disjuncture – by contrast, the project creates ongoing disjuncture as an open art project that appears to bypass the notion of the contemporary as a category altogether.

So the question arises here that if **Company** does not hold a mirror to the contradictions and problematics of the contemporary, and neither does it manifest itself through defined ontological boundaries, how do we address its simultaneous involvement in day-to-day realities and determinate social situations as both artistic practice and productive social activities of making and doing? The project creates a dispersed silhouette against the backdrop of the parklands and various communities it engages with, but this dispersal always points to its two connected core activities: the production of beer and other drinks and remembering histories of hop picking by families from east London. It is both grounded in, and informed by these realities; they are the constituents of the project as a whole, and mark out a conceptual space defined by movements and cycles that often run counter to mainstream neo-liberal market-based practices that govern the production and distribution of drinks.

The project's ontology might alternatively be thought through Chantal Mouffe's notion of 'agonistic struggle',[9] as creating a space where 'hegemonic struggle [can] consist in the attempt to create a different form of articulation among public spaces'.[10] Mouffe's proposition argues that artists can work towards 'subverting the dominant hegemony and ... contributing to the construction of new subjectivities'.[11] Her examples tend to be activist endeavours such as the Yes Men, but while **Company** is not explicitly an activist operation in this vein, it is involved in testing out alternative processes of production and distribution

within public contexts that produce new subjectivities. Furthermore, in its initiation by Myvillages, it does this within a wider network of similar practices that take place in different locations of the world. This gives it a broader political purchase on the realities it references, positioning its histories, processes and workshops within a discursive physical and conceptual space that attempts to re-organize those realities in real terms.

In fact, **Company** returns the realities of its activities as a historically connected drinks enterprise back to the realities within which it is situated. It therefore cannot be understood as a singular reality, or a 'whole' where all its constituent fragments have equal origins. Instead, by re-situating and grounding the project's elements in specific socio-temporal settings, it brings its realities into confrontation with existing realities and expectations of the realities it might have dislodged. In real terms, this re-situating and grounding might be under-stood through things like shifting people's expectations of how plants within the local area can be used, or exploring the potential for producing an alternative cola that situates itself alongside a global corporation, or the prioritising of an important working class history that relocates a community's role in wider social activities. In moving existing social structures of the realities it is engaged with and focussing on the interests of the community, the speculative propositions within the project can be seen as having political standpoints. The realities of these propositions are taken up through the configurations of temporalities that are at the same time contingent on wider realities like the weather, the daily lives of participants and what is botanically available.

De-Ontologization
Yet at the same time the artwork conducts itself as an economic enterprise. In this context, the aesthetic and social boundaries of the work start to dissolve, and become absent. In its moments of production it almost disappears. In so doing, it loses its speculative 'horizon' and its activities become the here and now, existing as theorist Stephen Wright might suggest as 'a context dependent set of tools, energies and competences'.12

In two essays, '& Then You Disappear' (2012) and 'Becoming Deontological – A Politics of Deontologizing Art / An Art of Deontologizing Politics' (2014), Wright proposes that the ontology of artworks that engage in social practices is not easily captured as a singular form or mode, nor does its open-endedness become a marker of a more indeterminate artistic singularity. The points where the work 'blends' apparently seamlessly into day-to-day activities within the community mean that there are no obvious 'aesthetic' boundaries as such. As competences Wright suggests that artistic practices become activities or expertise concealed from the art frame 'not as something that must be performed, but which might well exist as ... an active yeast or undercurrent beneath the visible field of events, all the more potent in that it remains

Left: Restocking the Company Drinks bar at Frieze Art Fair, Regent's Park, London, October 2014.

Right top: Company Drinks bar at Eastbrookend Country Fair, Dagenham, June 2015.

Right bottom: After the speeches, launch of the 2014 Company Drinks range, Eastbury Manor House, Barking, October 2014.

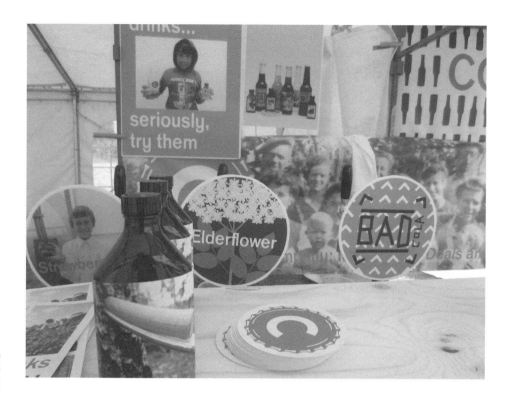

unperformed.'13 He asks: 'Can we not think of art as capable of a self-conscious, Bartelby-like decision to prefer not to (in this case, not to inject competence into the art frame) but instead to bide its time and, perhaps, redirect that competence elsewhere?'14

In this context, **Company** might be seen as a momentary merger of its fragments of historical and social events, which are always in the process of acting out social activities – for example, through workshops, drink production, foraging. These social activities can be understood as processes that work against the habitual and normative activities in terms of both drink production and local activities, while at the same time eluding easy ontological capture as art. Rather than defining them in any particular singular state therefore, the relationships between the activities, the artwork and their socio-political circumstances might then be understood as being embroiled in what Deleuze and Guattari refer to a process of 'becoming',15 where the political is inherently buttressed against the social limitations of what the artwork can be.

In this continual process, the limits of the social within the artwork are accounted for but equally they are breached by the work's nature. They are, in effect, in a continual state of de-ontologization. The drinks and the processes that produce them are continually challenging the possibilities of their social practice as both art and otherwise. The project binds strands together to create temporary forms, which then meet their limitations, before being continually breached as new temporary forms are created. This has the effect of high-lighting its limitations and the fluidity of these limitations. They are limitations not in the sense of things not being possible, but in the sense of what is possible. And these continued social possibilities are implicated in the project's limits every time they are breached.

NOTES

1
Brian Holmes, 'Art after Capitalism', in ed. Gregory Sholette, Oliver Ressler, It's the Political Economy Stupid (London: Pluto, 2013) p.166.

2
Jacques Rancière, The Future of the Image, trans. Gregory Elliot (London & New York: Verso, 2007) p.58.

3
Brian Holmes, 'Art after Capitalism', in ed. Gregory Sholette, Oliver Ressler, It's the Political Economy Stupid (London: Pluto, 2013) p.166.

4
Peter Osborne, Anywhere or Not at All: Philosophy of Contemporary Art (London & New York: Verso, 2013) p.48.

5
Peter Osborne, 'Contemporary Art Is Post-Conceptual Art'. Public Lecture at Fondazione Antonio Ratti, Villa Sucota, Como, July 9, 2010. Available at: www.fondazioneratti.org/mat/mostre/ Contemporary%20art%20is%20 post-conceptual%20art%20/Leggi%20 il%20testo%20della%20conferenza %20di%20Peter%20Osborne%20 in%20PDF.pdf, p.3 [accessed 19-06-15].

6
Ibid. p.3–4.

7
Peter Osborne, (2013) Anywhere or Not at All: Philosophy of Contemporary Art (London & New York: Verso, 2013) p.28.

8
Peter Osborne, 'The Post-Conceptual Condition. Or the Cultural Logic of High Capitalism Today', in Radical Philosophy 184 (March/April 2014) p.24 [pp.19–27].

9
Chantal Mouffe, 'Artistic Activism and Agonistic Spaces', in Art and Research. Vol.1 (2) (2007) p.3. Available from: http://www. artandresearch.org.uk/v1n2/pdfs/ mouffe.pdf [accessed 17-06-15].

10
Ibid. p.3.

11
Ibid. p.5.

12
Stephen Wright, 'Becoming Deonto-logical – A Politics of Deontologising Art/An Art of Deontologising Politics', in n.e.w.s (2014) [online] p.3. Available from: http://northeastwestsouth.net/ becoming-deontological-politics- deontologizing-art-art-deontologizing- politics [accessed 17-06-15].

13
Stephen Wright, '& Then You Disappear', in n.e.w.s. (2012) [online] p.4. Available from: http:// northeastwestsouth.net/then-you- disappear [accessed 17-06-15].

14
Ibid. p.4.

15
Gilles Deleuze, Felix Guattari, A Thousand Plateaus: Capitalism and Schizophrenia, trans. Brian Massumi (London & New York: Continuum, 2004).

MIRANDA POPE

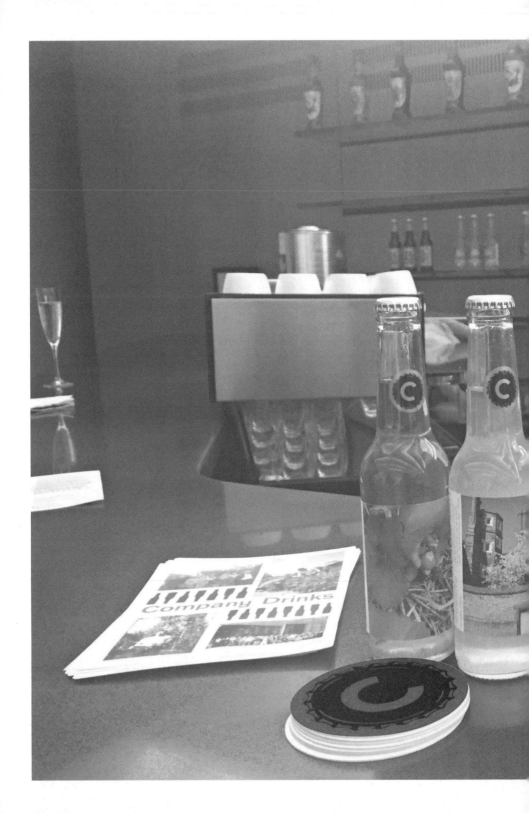

TIME AND LIQUID

Seb Emina

If you live in London, rare is the day you think, 'today I'm going to engage with a culture built around the drinking of a liquid', but even rarer is the day when you don't do exactly that. It's so commonplace as to be invisible. It's like the story David Foster Wallace once invented, to open a speech he gave to university graduates, the one in which two young fish meet an older fish. When the older fish asks them, 'how's the water?' they reply, 'what the hell is water?' Drinks are so much part of the way we live that they don't seem like much worth talking about. They certainly don't seem relevant to words like 'culture'.

Some years ago, a friend (Dan, a schoolteacher) and I took a pub crawl to the northern end of Walworth Road in south east London, a long street full of shops that are familiar to anyone who lives or grew up in a 'normal' London suburb: Argos, Kwik Fit, Sports Direct, William Hill. We started at Camberwell Green, at a pub called The Nag's Head. I must have walked past it a hundred times without ever even noticing it, so camouflaged had it become by decades of use and so universal and glance-overable was its name. It was only 8 p.m. but the barmaid locked the door behind us as we went in, which we quickly realized was so that patrons could smoke inside, it now being a 'lock-in' and thus a private party. Towards the back of the room, two or three families drank pints and watched TV while their children played a variant of tag. Tough men eyed us. And there was a woman who must have been ninety years old sat alone in silence in a coat that looked like fur with a glass of something fortified and sweet. She didn't read or look around but stared directly ahead into the middle distance. Her white hair was shiny and bouffant. Her make-up was perfect. The beatific look on her face said, 'this is one of my favourite regular moments'. I may have been projecting, but there was a sadness too. Did she used to come here with others? A husband? A group of friends? We didn't see her talk to anybody, but she was happy. For what? A drink? A place? An atmosphere? She just liked it: having this drink anywhere except for The Nag's Head at the allotted time would not have been the same.

The culture of drinking a drink is inextricable from the place in which it is drunk. I once went to one of the launch nights for the Frieze Art Fair in Regent's Park. To be clear, it wasn't the best launch, and I wasn't invited. This was the most public of private views, the one attended by thousands of people, the one everyone goes to and complains about the next day. It was the start of the Great Recession (when it was still known, breezily, as 'the credit crunch') and this had knock-on implications for the free drinks. There were some – none at all would be to say, 'this really is the end of the world' – but they were scarce. Occasionally I'd spot a tray of white wine in the distance only to see it instantly savaged: a lame rabbit, murdered by pumas. I slowly tracked these trays to their source and was shocked by what I found. The tray-people were emanating from a single door. People had realized the importance of this door, and were milling nearby. Their numbers were growing: they had amassed into a crowd,

hundreds strong. They were pretending to talk about art but were really waiting for a chance to consume 12.5 cl of wine without paying. The door hadn't opened for a while. The atmosphere was exactly as tense as it was pretending not to be. Eventually, a woman in an apron opened it and was confronted by this smiling, artfully dressed mob. Her tray held a laughably insufficient twelve flutes of Prosecco. The horde advanced politely but firmly, reaching, reaching. It must have been terrifying. She dropped the lot. 'Oh no!' someone said. 'Oh no!' The woman looked at them, at first with alarm then with a deep sadness. She vanished back through the door. Nothing but a pool of wine remained, sparkling only with shattered glass. Some were staring at it, and it seemed a bit like the only thing holding them back from getting on their knees and licking at the fringes of the booze was the presence of other people.

'Will there be food and drink?' people ask when they're invited to parties. Food and drink: forever the essential pair. But they aren't exact equivalents. The drink world has a centre. Water is ultimately the only drink we need. The food world has nothing that serves this purpose. There is no neutral, normal thing we can eat at the expense of everything else. In the realm of drinks, the word for 'everything apart from water' is 'beverage', and if we think of life in a purely reductionist way, then a beverage – a cup of tea, a glass of wine, a can of pop – is a mere indulgence, a sort of libatory trip to the cinema. Except that most people take beverages much more seriously than they do art.

After we had visited The Nag's Head, Dan and I walked north. The next pub we saw was Corrib Bar, probably named after Lough Corrib, which is a lake in Ireland. There were three separate doors, each on a quite different aspect of the building. We pushed through the central one. It led to a bright, small room containing half a dozen four-person tables, with a different, solitary elderly man sat at each. One of these men was talking loudly. I didn't hear everything he was saying but it was about the year 1971. The room was very awkward. I would say that it felt like 'someone else's living room' but it didn't feel anything like a living room. It felt like a room of a kind I'd never been into before, with rules and etiquettes that were unknown. That's exactly what it was, I suppose. At the bar it became clear that each of the other doors in fact led into an entirely distinct pub, so to speak, with one bar, and one barmaid, acting as a link between them. This one seemed to belong, immutably, to the old men. The 1971 man kept speaking, and none of the other four responded. They were all sitting at their own tables, looking lonely, with pints of ale. Why didn't they join each other? We'll never know, as at the barmaid's pointed suggestion, Dan and I left and re-entered through the east door. This was a bigger and slightly more comfortable chamber. A tall, quiet man and a short, tough-looking woman were stood by the bar and two other men were near the window. All had pints. The woman at the bar was speaking to the man with

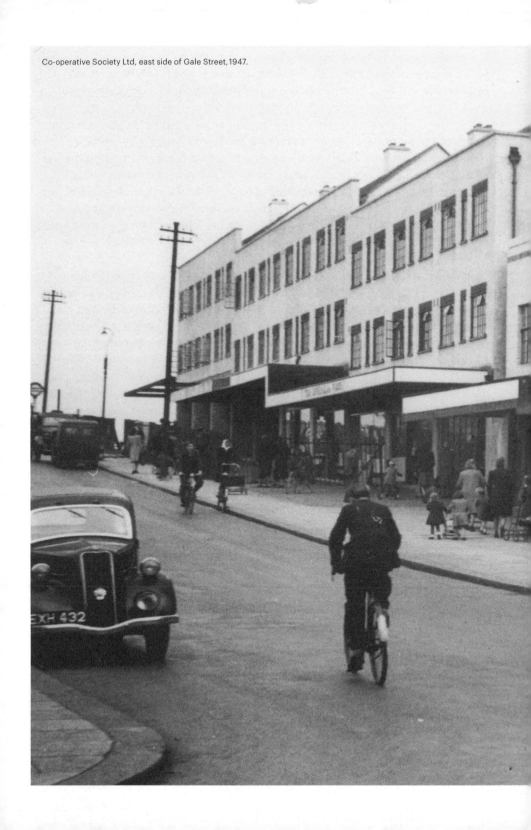

Co-operative Society Ltd, east side of Gale Street, 1947.

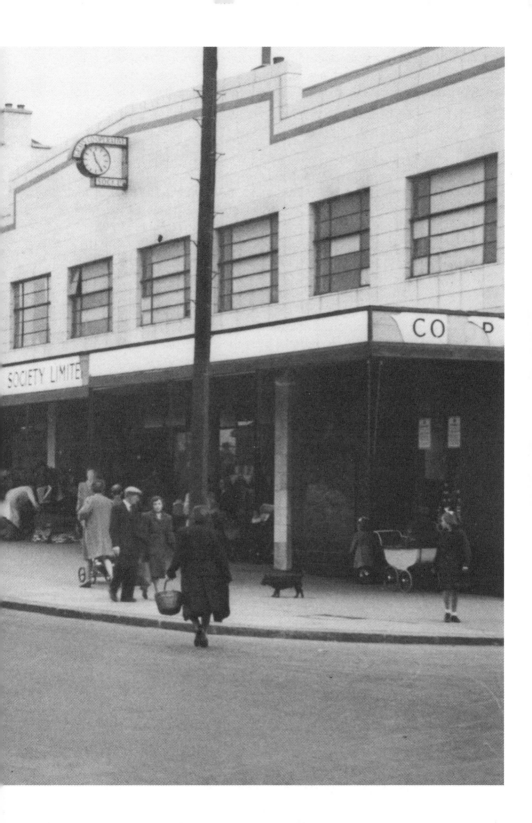

feverish intensity. 'Has someone done you a fucking wrong?' she was asking him, in different ways, at such a volume that it filled the room. We drank our drinks quietly, as it seemed feasible that, were we to make an unwise gesture or say anything that could be overheard and misconstrued, we could be deemed to have done this man a wrong.

The most openly ritualistic drinks, tea and coffee, were popularized having initially been used for religious worship: coffee came from Sufis in North Africa, tea from Buddhist monks in the Far East. In his 1906 treatise **The Book of Tea**, the Japanese writer and scholar Kakuzo Okakura argued that the preparation of tea was, like it or not, a religious act. His ideas, which relate to the rituals and importance we attach to non-essential things – especially when they're beverages – could easily be applied to coffee as well, but they also offer insights into the way we crave soda, or smoothies, or alcohol.

I went to a school called Forest Hill Boys, which, back in the 1990s, was known by the media shorthand as an 'underperforming comprehensive'. Two significant locations for all students were the corner shop nearest the school and the vending machine in the foyer. These were the sources of our chocolate bars and soft drinks. There was a lot of interest in soft drinks. When you were seen holding one, your choice of brand was noted, weighed up, discussed, perhaps denigrated. Many conversations were had about the merits, or otherwise, of Cherry 7-Up, Vanilla Coke, and other short-run promotional flavours. The truth is, I'm not sure how much any of us actually enjoyed the taste. Drinks in cans were just something to do, a make-do-and-mend cultural activity.

At some point, it became inexplicably fashionable to pour some of your beverage onto the ground before you began drinking it. Nobody knew how this started but it was soon compulsory. Not to pour was to announce yourself as a do-gooder, a rule-follower, a nerd. Nobody in his right mind would announce himself thus. So I poured. So did Peng Voong, the maths prodigy. So did Bradley Saunders, the computer geek. After a while, a kind of inflation set in: the pours began to get longer. The longer the pour, the greater the statement of – what? Toughness? Rebellion? Nihilism? Free will? I suppose all these things, on some level, though obviously no one ever analysed it in that, or any way. Whatever it meant, it was everywhere. For perhaps as long as a year the streets around the school had the sweet reek of pointlessly discarded soda. Then, one afternoon, David Winch, a feared fellow pupil, but also a bit of a loner, emerged from the corner shop with a can of Coke and poured it onto the ground as usual. Except this time he kept pouring until the can was empty. Word of this got around, accompanied by mutterings and slow shakes of the head. The craze had reached an apex. The apex was absurd. Almost instantly, people stopped pouring their drinks on the ground.

In London, the drink that is most often spoken of with the reverence accorded to high tradition is tea; and to high art, coffee. An item on plenty of tourist schedules is afternoon tea. It will occur in a high-ceilinged room. Waistcoated men and women who act like it's the eighteenth century serve Darjeeling, sandwiches and cakes. The cheapest afternoon tea at The Ritz is £50, and it's almost impossible to consume so much that you end up thinking 'great deal!' when you emerge into the Mayfair traffic. That is, of course, not the point. You pour some of your money on the ground and in return you receive an aura of prestige. As for coffee, despite the city's visceral loathing for the hipsters it thinks are responsible, it has never been better (in fact, improvements in the quality of coffee are the hipster movement's greatest achievement). Business meetings often take place 'for coffee' because if you just meet with someone, and there's no beverage involved, it's a vulgar acknowledgment that this is actually a form of labour. There are coffee magazines. There's a coffee festival. All things considered, coffee seems utterly modern compared to tea, but it actually arrived in Britain in the sixteenth century, almost a century ahead of its leaf-based cousin.

The next pub on the Walworth Road was The Red Lion, just opposite the famous Mixed Blessings Bakery. Unlike the others, it was busy. A blackboard outside advertised live music and, indeed, on a small stage in the corner of the room were two musicians. One was in his forties, the other his twenties. The younger man was stood playing an accordion. The older man was sat on a high stool, deftly pressing at a keyboard, softly singing into a microphone. From the belt buckle by the pocket of his jeans dangled a key ring to which at least twenty keys were attached, some tiny padlock openers, others seemingly from a Victorian dungeon. The amazing thing about the two musicians was that they were lit by the green light of a football game on a huge plasma screen on the stage directly behind them. It was The Red Lion's ingenious solution to a gig that clashed with a match: this way, we could watch both at the same time. Men and women, teenagers, parents and pensioners drank pints of lager or spirits with mixers. The duo launched into a ballad, 'Fields of Athenry', an Irish song about a man saying goodbye to his wife and children as he leaves on a prison ship, having been sentenced to exile in Australia for the crime of stealing food. It's a popular sports song. The crowd in The Red Lion sang along.

There were two more pubs on the Walworth Road, neither quite so memorable as any of these first three. One was a chain, the kind of pub you find in an airport. The other was a grey room, empty except for the barman, with house music playing at a nightclub volume. But still, when we reached Elephant and Castle, we swore we'd make this format a regular event; repeat it on different streets, in different suburbs. Somehow, we never got round to it: Dan eventually left the country and moved back to California.

404.

To Brew Heath Beer.

Mrs Hiks.

Take a Kilderkin & 2 or 3 Galons of
because of wasting in the boiling; div
into 3 parts, first boil one part wit
& Ginger, then put it into your mesh
& let it Stand halfe a quarter of an
then put to it a bushel of Molt & le
Stand one hour til you have made th
part boiles, then let the first run & 2
the Seacond to doo 3 times still boiling
Liquor with Ginger & heath, & if it
lear from the Molt boil your ____
litle, & when it is Could put it all 2
& let it to worke with a great of.
& the next day tun it into your Kil
3 ounces of Ginger beaten very Sma
2 good handfuls of Heath is enough
the Smale Beer at Jenkers has too bushel of Molt
to a Hogshead which the brewer there says is Strong
then the 8 Shiling Beer at London

An Electuary for the Cough of y Lu

Mrs Grantham;

Take 8 ounces of rasons of the Sun Stones
them in a Stone Morter very Smale, th
take 4 ounces of brown Sugar Cand y
very fine; then take halfe a pound of
of red roses; mix all these well togethe
take 12 drops of the Oyle of Sulpher, & 2
of the Oile of Vitrevll, & one ounce of
of Diozodium mix them all wel tog
& take of this morning & evening, the q
of a nutmeg, if the party have a loom
must leave out the Syrups, add 1 ounce of

Pruner: Take a dozen of fair pipins, pair them & cut them
as fast as you pare them into a quart of Spring
water boiling upon the fire, let it boile til it come
to a thick pulpe then take to every pound of pulpe
a pound of double refined Sugar; boil your Sugar
in a Clean skilet to a very high Candy, then pour
your pulpe into it, stir it upon the fire as long as
you can for fear of burning, take it off & put in
juice of Leman And Leman peil, raw & sliced
according to y'tast, Glass them up in Clear Cake Glasses
& stove them & when they are dry about turne them
out upon sheets of Glass & so dry them up as Clear Cakes.

To make Cherry Brandy.

Mordant: Fil a 2 quart Glas with a wide mouth, full of
Morella or Kentish Cherrys, within 2 inches of the
top & as you put in your Cherrys strew amongst them
a quarter of a pound of whit Sugar Candy, finly beaten
then fil your Glas to the top with the best brandy you
Can get Stop & tie it up Close, & let it stand about
2 or 3 months & then draw off the brandy into quart
bottles Stop them & keep them for your use.

To pickle all manner of Salads;

Adamson: Make a pickle of 2 parts Vinegar & 1 part water
boil it & put some salt into it; put it in an earthen
pot to keepe, & when y' Purselaim or lettice is fit
Cut them in lengths to your liking & put them
into this pickle, & at your leasure a Month or so
after take your Salads out of this pickle, & put
them into a Stew pan of fair water, Cover them
up on the fire & when they begin to boile take
them off & let it but so boil.

I only read **The Book of Tea** recently. One of its more beautiful explanations for the importance of tea is that it is 'an attempt to accomplish something possible in this impossible thing we describe as life'. By and large Kakuzo Okakura was writing of the formal Japanese tea ceremony, in which tea is taken on specific mats in specific rooms, in a carefully choreographed event controlled by a painstakingly trained tea master. But these ceremonies are not the cause of tea's importance, but a response to it. When I read his words I also thought of the handwritten spreadsheets in office kitchens specifying the exact milk and sugar preferences of everyone in the company, the Victoria sponge and tea get-togethers at Women's Institute meetings in Kentish church halls, and the hardy white mugs of 'builder's' served with bacon, egg and chips in greasy spoons on high streets like Walworth Road. I also remembered the woman with white hair in The Nag's Head, teenagers trying to be macho by pouring soft drinks all over the pavement, people at art openings who just want to feel that they are at an art opening, and all the other oddly touching moments that only happen thanks to the cult of unnecessary beverages.

TIME AND LIQUID

Lemonade truck, Deal, Kent.
Photo courtesy of Hadrian Garrard.

Company Drinks bar at Frieze Art Fair, Regents Park,
London, October 2014.

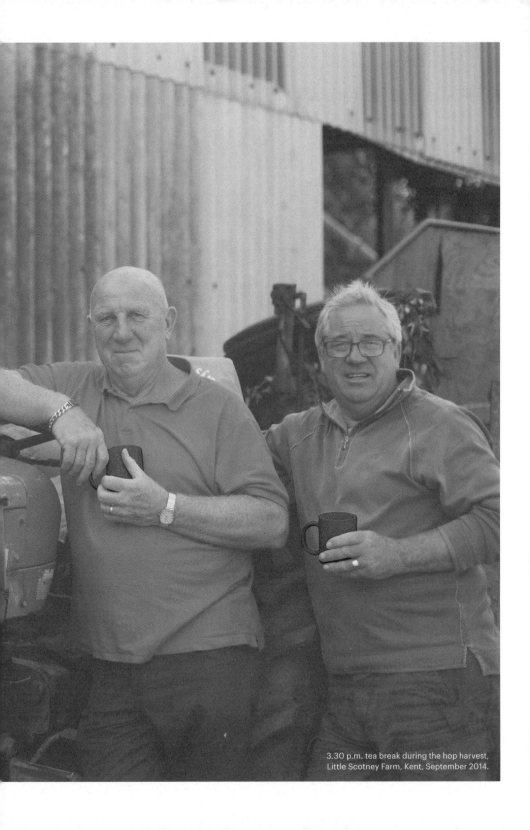

3.30 p.m. tea break during the hop harvest,
Little Scotney Farm, Kent, September 2014.

ABOUT THE AUTHORS

Editors

Kathrin Böhm is a London-based artist with a long-standing interest in the collaborative making and extending of public spaces through methods of collective production, distribution and usage within both urban and rural situations. Kathrin is a founding member of the international artist group Myvillages and the London-based art and architecture collective Public Works. Public Works' public realm and design projects include **Park Products** for Serpentine Galleries, London (2004), **1000 bags here and now** for Whitechapel Gallery, London (2007) and **Folk Float** for Creative Egremont commissioned by Grizedale Arts (2007). Böhm has recently curated **Trade Show** together with Gavin Wade for Eastside Projects in Birmingham (2013) and **R-Urban** in Paris (2014). She is organizing monthly **Haystacks** events that address connections between urban and rural practices and realities. Current and recent projects with Myvillages include **Vorratskammer / Pantry** at House of World Cultures in Berlin (2011), **Good News from Nowhere** at the Architecture Foundation London (2013); and Böhm is the leading artist on the Myvillages **Company: Movements, Deals and Drinks** project.

Miranda Pope is a London-based writer, editor and curator. Her work focuses on relationships between experimental curatorial practices and notions of the ecological and she is currently completing a PhD in the Art Department at Goldsmiths College. Projects include: **Overland: London to Beijing**, a curatorial journey in which a Tobias Rehberger artwork was exhibited in London, Istanbul, Almaty and Beijing (2009–2013); **The Occurrence of Malformation in Toads and Frogs**, a monograph of Brandon Ballengée's work (2009) and **Nuclear Conversations**, interviews about nuclear issues with artists and scientists like Jim Al-Khalili and Pete Cusack (2009). She has also worked with Arts Catalyst, Camden Arts Centre, Goethe-Institut London, Hollybush Gardens, Platform Garanti Istanbul, and think tank Curating Architecture among many others, and regularly contributes essays and reviews to blogs and journals.

Myvillages is an artist group founded in 2003 by Kathrin Böhm (UK / DE), Wapke Feenstra (NL) and Antje Schiffers (DE). The work addresses the evolving relationship between the rural and the urban, looking at different forms of production, pre-conceptions and power relationships. Myvillages initiates and organizes international artistic projects which range from small-scale informal presentations to long-term collaborative research projects, from work in private spaces to public conferences, from exhibitions to publications and from personal questions to public debate. Current and recent projects include **International Village Show** (2014–2016) for the Museum of Contemporary Art Leipzig, DE, **Lending Shape to Form** (2015), A–Z Marzona Collection, Hamburger Bahnhof, Berlin, DE and **Farmers and Ranchers** (2012–2015) with M12, Colorado, US and the Fries Museum, NL.

Authors

David Boyle is a British author and journalist who writes mainly about history and new ideas in 'economics', money, business and culture. He is co-director of the New Weather Institute and was the government's independent reviewer for the Boyle Review of Barriers to Choice, commissioned by the Treasury and Cabinet Office, in 2012–2013. He is the author of a range of books about history, social change, politics and the future, such as **Broke: How to Survive the Middle Class Crisis** (Fourth Estate) and **On the Eighth Day God Created Allotments** (Endeavour Press) and has been editor of a number of publications including **Town & Country Planning, Community Network, New Economics, Liberal Democrat News** and **Radical Economics.**

Céline Condorelli is a London-based artist who makes supporting structures; she is currently Professor at NABA (Nuova Accademia di Belle Arti) Milan, and one of the founding directors of Eastside Projects, Birmingham, UK; she was the author and editor of **Support Structures** published by Sternberg Press (2009). Recent exhibitions include **bau bau,** Hangar Bicocca, Milan, IT (2015), **Céline Condorelli,** Chisenhale Gallery, UK, **Positions,** Van Abbemuseum, NL, including the publication **The Company She Keeps,** with Bookworks, and **bau bau,** Museum of Contemporary Art, Leipzig, DE; and she curated **Puppet Show,** Gävle Konstcentrum, SE, and Grundy Art Gallery, UK (all 2014). Previous shows include **Additionals,** Project Art Centre, Dublin, IE, **Things That Go Without Saying,** Grazer Kunstverein, AT, **The Parliament,** 'Archive of Disobedience', Castello di Rivoli, IT (2013) and **There Is Nothing Left** Alexandria Contemporary Arts Forum, EG and Oslo Kunstforening, NO (2011–2012), Manifesta 8, Murcia, ES (2010).

Seb Emina is a British writer, journalist and editor-in-chief of **The Happy Reader,** an international, award-winning magazine, published by Penguin and devised by **Fantastic Man.** He is the author of **The Breakfast Bible,** a breakfasters' compendium of recipes, essays and miscellany published by Bloomsbury, and, with Daniel Jones, co-creator of **Global Breakfast Radio** (www.globalbreak fastradio.com), perpetually broadcasting local radio from wherever in the world the sun is rising. His writing, on subjects such as liquorice, south London, pockets and literature has appeared in newspapers, books and magazines internationally. These include **FT Weekend,** the **Guardian Review, The Gentle-woman, VICE,** and the **Times.** A former employee of arts organization Artangel, he has worked with artists including Ryan Gander, Roger Hiorns and Susan Philipsz. Emina was born in Wiltshire, raised in Birmingham and London, and now lives in Paris.

Paul Hogan is the Divisional Director of Culture and Sport at London Borough of Barking and Dagenham. He started his career at the Everyman Theatre in Liverpool where he was administrator of Spiral Dance Company and Delado African Drum and Dance Company before moving on to becoming Director of the Citadel Arts Centre in St Helens and later Principal Arts Officer for Renfrewshire Council followed by stints at councils in Leicestershire and Derbyshire. In addition to his work responsibilities Hogan has been a trustee of the Spark Children's Theatre Festival and is currently trustee of a community managed library and a local community sports club.

Gilda O'Neill was a popular historian and novelist. Her social histories, such as the oral history Pull No More Bines – Hop Picking: Memories of a Vanished Way of Life (1990) for the Women's Press (it was reissued as Lost Voices in 2006), My East End: Memories of Life in Cockney London (1999) and its sequel, Our Street: East End Life in the Second World War (2003), as well as The Good Old Days: Crime, Murder and Mayhem in Victorian London (2006), gave voice to east London experience and memory at a time when both were rapidly transforming or disappearing. Underneath that cockney persona, she figured out how to use storytelling, lived experience and memory to draw political parallels. Her novels, including family sagas such as The Bells of Bow (1994) and Just Around the Corner (1995), drew on similar material.

Constantin Petcou is a Paris-based architect whose work stresses the intersection between architecture, urbanism and semiotics. He has co-edited Urban Act: A Handbook for Alternative Practice (2007) and Trans-Local-Act: Cultural Practices Within and Across (2010). He is a co-founder of atelier d'architecture autogérée (aaa), a collective that conducts explorations, actions and research concerning socio–political practices in the contemporary city. The most recent project R-Urban proposes a bottom-up framework for resilient regeneration based on networks of civic hubs and circular economy principles. aaa has been laureate of the Zumtobel Prize for Research and Initiative 2013, the European Prize for Urban Public Space 2010 and the Prix Grand Public des Architectures contemporaines en Métropole Parisienne 2010 and has been finalist of EIB Social Innovation Prize 2014. aaa is also finalist of the prestigious international competition Reinventing Paris 2015–2016.

Doina Petrescu is a Professor of Architecture and Design Activism at the University of Sheffield. She is the other co-founder of atelier d'architecture autogérée. Her research focuses on gender and space in contemporary society as well as participation in architecture. Her approach broadens the scope of architectural discourse by bringing cultural, social and political issues to inform the design and thinking processes in architecture. Her research methodology combines approaches from architectural theory and design, contemporary arts, social sciences, political philosophy and feminist theory.

She is the editor of **Altering Practices: Feminist Politics and Poetics of Space** (2007) and co-editor of **Architecture and Participation** (2005), **Urban Act** (2007), **Agency: Working with Uncertain Architectures** (2009), **Trans-Local-Act: Cultural Practices Within and Across** (2010) and co-editor of **The Spatial (Re-) Production of Architecture** (Routledge, 2015).

Marijke Steedman is a curator with a specific interest in the political meaning of art and the significance of notions of education, community and location. She is currently the Curator for Create. She worked for seven years curating the Community Programme at Whitechapel Gallery, and before that at Tate Britain. She has worked closely with many artists including Marvin Gaye Chetwynd, Nedko Solakov, Jens Haaning, Emma Hart and Matt Stokes and has worked with writers including Lars Bang Larsen and Grant Kester. She edited the Whitechapel Gallery publications **Gallery as Community: Art, Education and Politics** and **Reclaim the Mural.**

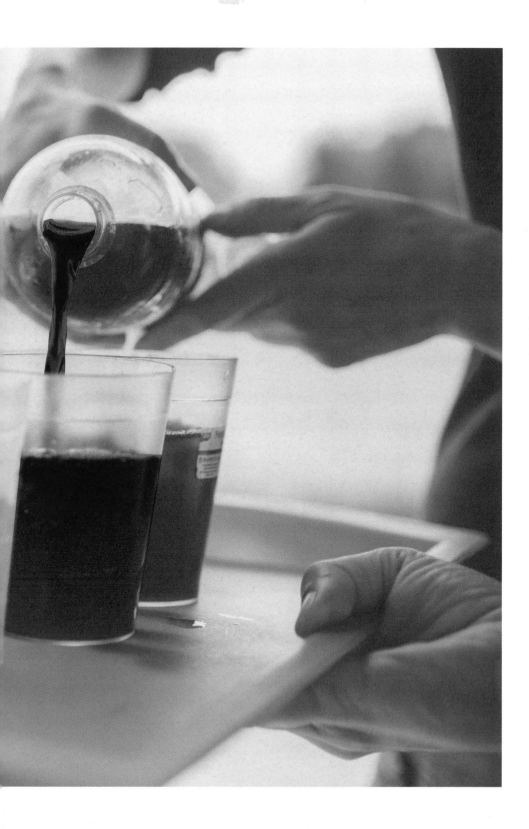

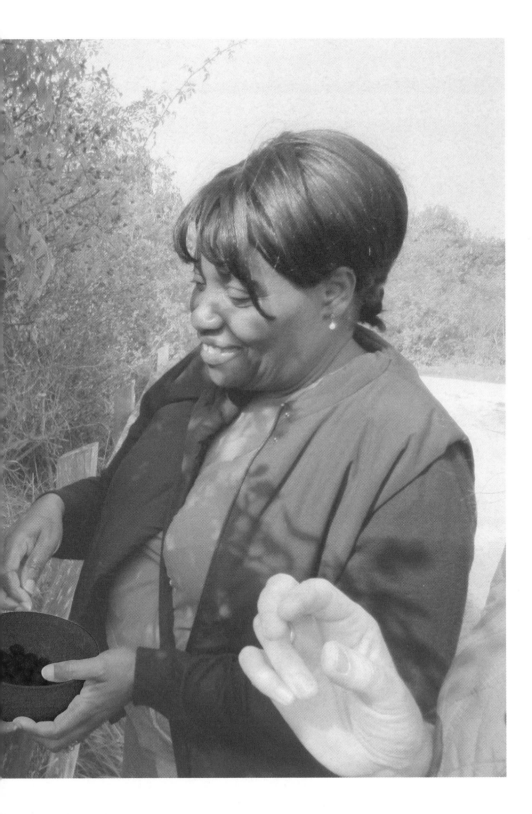

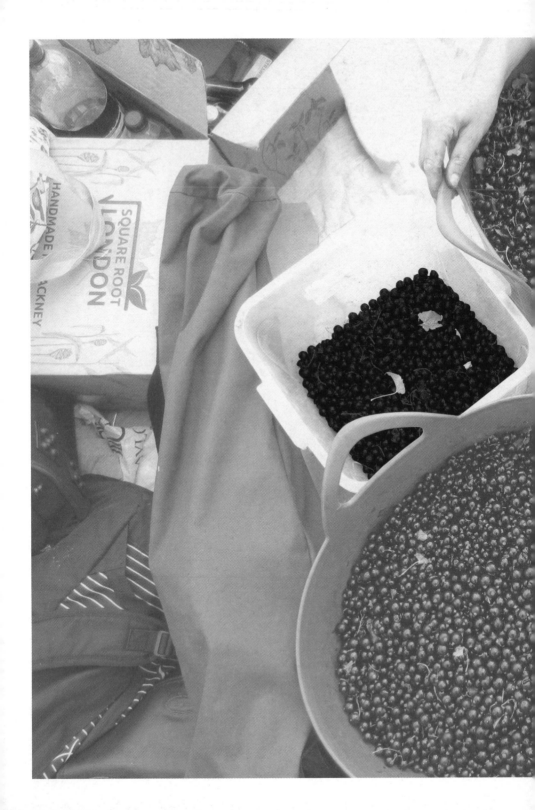

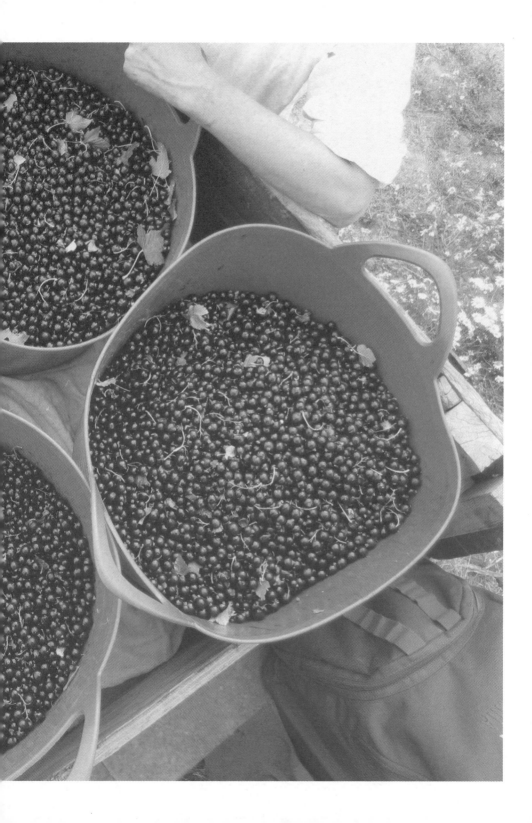

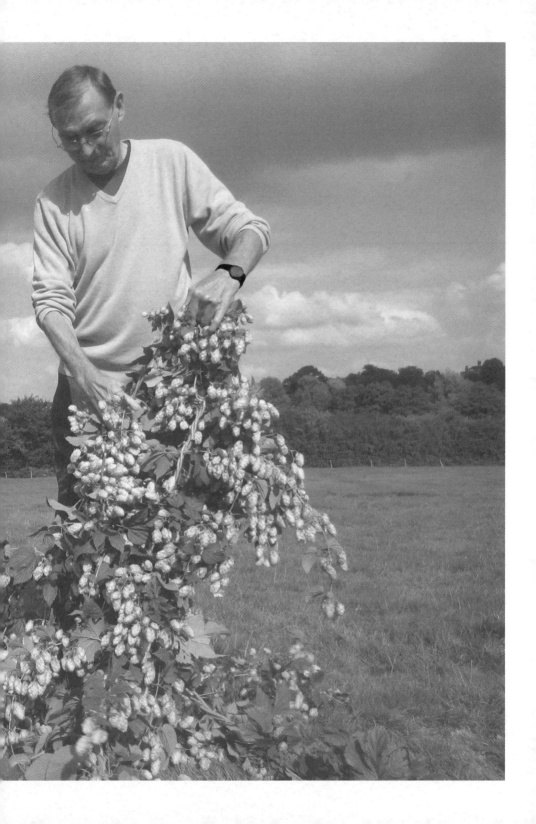

THANK YOU

Company: Movements, Deals and Drinks is a project by Myvillages which links the history of east Londoners going fruit and hop picking in Kent to the set up of a new community drinks enterprise in the London Borough of Barking and Dagenham. The project was commissioned by arts organization Create and was selected as the winner of the 2014 Create Art Award, which was supported by Bank of America Merrill Lynch. In 2015 the project registered as a Community Interest Company with the name Company Drinks. www.c-o-m-p-a-n-y.info

Myvillages would like to thank the many individuals, groups and organizations that have supported and joined the Company endeavour. In particular, the Create team and Hadrian Garrard and Marijke Steedman for crucial strategic work and key deals-making, and the London Borough of Barking and Dagenham for financially supporting the project, supplying office and workshop space at Park Centre and for allocating trading space at many of the borough's public events. Thanks also go to Dagenham Library for being fully involved in running trips and workshops; Valence House Local Archive for hosting the monthly hopping reminiscence sessions; the park rangers for allowing us to forage; the farmers who give access to their land and crops; Barking and Dagenham College staff and students for regularly going picking and brainstorming new drinks concepts; Growing Communities Dagenham Farm for growing and propagating space, and delicious organic strawberries; William Bellamy School and Eastbrookend Comprehensive School for numerous school hours spent picking, Studio 3 Arts and Cultural Connectors for their support and help with local networking and rooting. We would also like to thank the many growing groups, wild plant enthusiasts and drinks makers who have advised, supported and supplied services, including Square Root and Kernel Brewery for making the delicious sodas and beer, and Kate Rich and Kayle Brandon for showing and teaching us how to make cola from scratch. The project has been run by a strong and enthusiastic team, without which we would not have been able to grow, especially Susanna Wallis, Pip Field, Cam Jarvis, Antonia Halse and Shahana Begum. We are also indebted to the steady group of weekly volunteers that contribute necessary extra help, knowledge and encouragement.

We would like to thank all the authors of this publication for generously sharing their knowledge, ideas and stories, and our close colleagues and friends for providing intellectual and practical support.

A big thank you goes to Robyn Kirkham and Harry Blackett from An Endless Supply for injecting distinct and humorous design into the project's identity and Niels Schrader for coming up with a book design that captures the many dialectics involved in the project. Finally warmest thanks go to Eleonoor Jap Sam of Jap Sam Books for all her encouraging words and smooth logistical work on this book.

Editors
Kathrin Böhm (Myvillages), Miranda Pope
www.myvillages.org

Text and contributions
Kathrin Böhm, David Boyle, Céline Condorelli,
Seb Emina, Gilda O'Neill, Doina Petrescu
and Constantin Petcou, Miranda Pope, Marijke
Steedman

Reprinted Texts
—The Women and Why They Picked, Lost Voices,
Gilda O'Neill, published by Arrow Books in 2006,
Random House, London.
—R-Urban Resilience by Doina Petrescu and
Constantin Petcou, is published here in shortened
version of a text first used in 2012 for ATLAS:
Geography, Architecture and Change in an
Interdependent World by Tyszczuk, R., Smith, J.,
Clark, N. & Butcher, M., Black Dog Publishing,
London, 2012.

Editorial assistance
Elea Himmelsbach

Proof reading
Aaron Bogart, Eleonoor Jap Sam

Photography and Artworks
atelier d'architecture autogereé (98, 101, 102);
An Endless Supply: cover inside (logo), 129–144
(labels and graphics); Jennifer Balcombe (26–27,
129–144, 173); Kathrin Böhm (2–7, 14–19, 32, 40,
80b, 81, 88, 108–109, 114–115, 123, 150, 154–155,
157, 160, 161b, 168–169, 186t, 171t, 216, 220–231,
234–237); Emil Charlaff (10–11, 20–21, 151, 165,
182–183, 186b, 190, 191b, 207b, 218–219, 232–233);
Elena Heatherwick (8–9, 41, 48–49, 80t, 85,
93b, 122, 187, 208–209); Laura Vila Lafuente (12–13,
126–127); The Mayor and Burgesses of the London
Borough of Barking and Dagenham (71–75, 84,
93t, 118–119, 156, 176–177, 198–199); Jake Powell
(44–45); Wellcome Trust Collection (214–215).

Design
Mind Design, Amsterdam
Niels Schrader
www.minddesign.info

Printing
Oro Grafisch Projectmanagement, Koekange
www.orogpm.nl

Publisher
Jap Sam Books, Heijningen
www.japsambooks.nl

Typeface
Graphik, Schwartzco Inc., New York

Paper
Munken Polar 100g

© 2015
Myvillages, the authors, the photographers,
artwork suppliers and Jap Sam Books

Company: Movements, Deals and Drinks is the
third book by Myvillages in an ongoing publication
series with Jap Sam Books. Previous books in
the series are Images of Farming (2011), edited
by Antje Schiffers and Wapke Feenstra and
A Photographic Portrait of a Landscape.
New Dimensions in Landscape Philosophy (2013)
edited by Pietsie Feenstra and Wapke Feenstra.

ISBN
978-94-90322-56-4

Company: Movements, Deals and Drinks
was commissioned by Create
www.createlondon.org

The project is supported by Barking and Dagenham
Council and Bank of America Merrill Lynch